# SOMETHING OF SPLENDOR

## Decorative Arts from the White House

# SOMETHING OF SPLENDOR

*Decorative Arts from the White House*

*An exhibit at the Renwick Gallery
of the Smithsonian American Art Museum*

October 1, 2011, to May 6, 2012

William G. Allman and Melissa C. Naulin

THE WHITE HOUSE
HISTORICAL ASSOCIATION
50TH ANNIVERSARY

The White House Historical Association is a nonprofit organization, chartered on November 3, 1961, to enhance understanding, appreciation, and enjoyment of the historic White House. Income from the sale of the association's books and guides is returned to the publications program and is used to acquire historic furnishings and memorabilia for the White House.

Address inquiries to:
White House Historical Association
740 Jackson Place, N.W., Washington, D.C. 20006
www.whitehousehistory.org

Vice President, Publications: Marcia Mallet Anderson
Publications Specialist: Nenette Arroyo
Editorial Consultant: Ann Hofstra Grogg
Principal Photographer: Bruce White
Design: Yaciniski Design, LLC
Prepress: Peake-Delancy Printers, Cheverly, Maryland

Published in association with the
Office of the Curator, The White House,
Washington, D.C.

ISBN 978-1-931917-13-1
Library of Congress Control Number 2010940638

Printed in Italy

*Opposite: Coverlet (detail), made by First Lady Grace Goodhue Coolidge (see p. 64)*

# CONTENTS

# FOREWORD

## from the White House Historical Association

THE WHITE HOUSE HISTORICAL ASSOCIATION is delighted to present *Something of Splendor: Decorative Arts from the White House*. It marks our fiftieth anniversary, and we are very pleased to be joined by our neighbors, the Renwick Gallery of the Smithsonian American Art Museum and the Office of the Curator, The White House, in commemorating this milestone. This catalog supports an exhibition at the Renwick featuring historic furnishings and artworks from the White House collection, many of which were acquired with the association's assistance.

In 1961, prompted by her desire to make the White House a living museum, First Lady Jacqueline Kennedy initiated a three-part program to restore the historical integrity of the mansion's public rooms, acquire a collection of fine and decorative arts, and establish a private nonprofit organization to research and publish books and educational materials interpreting the White House and its history. She told the *Life* magazine columnist Hugh Sidey, "It is such a beautiful old building. It is so bound up in our history. We need to bring it back to the way the founders envisioned." On November 3 of that year, the association was chartered to help accomplish these goals. Every first lady since then has taken an active interest in and supported the work of the association.

From the beginning, the association has provided major financial support for refurbishing the historic interiors of the White House's public rooms and for conserving its fine and decorative arts collection. It has also provided funding for the acquisition of objects for the permanent White House collection, and assistance to the National Park Service in preserving the White House and interpreting its history to the public.

We hope that those who visit the exhibition come away with a better understanding of the rich history of the White House and that those who purchase this catalog will enjoy an enduring record that further fulfills Mrs. Kennedy's vision of a living museum.

NEIL W. HORSTMAN
*President*
*White House Historical Association*

# FOREWORD

## from the Smithsonian American Art Museum and the Renwick Gallery

T IS ESPECIALLY APPROPRIATE that the Renwick Gallery host an exhibition of decorative arts from the White House, for just as First Lady Jacqueline Kennedy was responsible for restoring its historical integrity, so was she instrumental in rescuing the Renwick. Now named for its architect, James Renwick, the building is America's most beautiful example of the Second Empire French style of architecture. This elegant style debuted in Paris with the 1850s addition to the Louvre and was immediately adopted by Renwick for the new museum he was building for William Corcoran's art collection, just across Pennsylvania Avenue from the White House. The presence of a distinguished art museum so near the President's House symbolized America's new ambitions for the arts. In subsequent decades, Corcoran moved his collection into larger quarters and the federal government took over his building; by the 1950s, it was slated for demolition. But Mrs. Kennedy recognized it as a treasure and—like the White House furnishings she was then reclaiming—an irreplaceable part of our nation's history. She rallied support to save the building and persuaded President Lyndon Johnson to donate it to the Smithsonian for use as a museum of decorative arts—a gift to all Americans.

Each artwork in *Something of Splendor* has a rich story to tell, and White House curators William Allman and Melissa Naulin are gifted tellers of these stories. They bring each object to life through its special place in the narrative—which artist created it, which president or first lady desired it, why a particular style was chosen, how it served quotidian or ceremonial purposes, and more. Through their eyes and the lens of history, we see these rare objects as touchstones of our democracy and markers of our civic leadership. We cannot know the presidents and first ladies who are gone, but through the objects they chose to live with, we can understand something of their dreams for the nation. *Ars longa, vita brevis,* to quote Hippocrates.

As the White House Historical Association begins its second half century, we are honored to celebrate its service to the nation and to salute all who cherish the President's House and the artworks that embellish it.

ELIZABETH BROUN
*The Margaret and Terry Stent Director*
*Smithsonian American Art Museum and the Renwick Gallery*

# INTRODUCTION

A S THE OFFICIAL RESIDENCE OF THE PRESIDENT OF THE UNITED STATES for more than two hundred years, the White House has become an important symbol of our nation, embodying the ever-evolving story of how the presidents and their families live, work, and entertain within its historic walls and among its historic furnishings. The interiors of the White House have changed often during that time, but how to furnish appropriately the official lodgings of the president was a question even before the new capital city of Washington and a new president's house had been conceived. In 1789, our first president-elect, George Washington, shortly before leaving for his inauguration in New York, commented: "It is my wish and intention to conform to the public desire and expectation, with respect to the style proper for the Chief Magistrate to live in."[1]

Washington's successor, John Adams, moved to the new President's House in Washington in November 1800, at which time he wrote his wife Abigail with a famous sentiment (now inscribed on the State Dining Room mantel):

> I pray Heaven to bestow the best of Blessings on this House and all that shall
> hereafter inhabit it. May none but honest and wise Men ever rule under this roof.[2]

The furnishings Adams brought with him, along with those acquired by Presidents Thomas Jefferson and James Madison, were destroyed when the British burned the house in 1814 during the War of 1812. The refurnishing of the rebuilt house by President James Monroe included many high-style French objects, but in 1819, the artist and inventor Samuel Morse commented on the importance of those much-criticized furnishings, saying that, for the "credit of the nation" it was appropriate for the President's House to display "something of splendor."[3]

Often at the forefront of American fashion, though at times a bit worn or shabby, the nineteenth-century White House interiors were refurbished repeatedly. This is not to say that the White House was redecorated by each new first family; styles did not change that quickly, nor did Congress provide sufficient funds for such

extravagance. In fact, changes were often accompanied by the rather drastic practice of selling off out-of-style furnishings, what was called "decayed property," by what amounted to White House garage sales at local auction houses. Much of the old was swept out as the new was ushered in.

The public sometimes felt the interiors were excessively splendid. In the 1840 presidential campaign incumbent President Martin Van Buren was excoriated by his Whig opponents for having spent additional money on the "sumptuous" and "dazzling" rooms.[4] One Whig congressman, however, defended Van Buren, saying: "He is . . . the host of the nation. His guests are the guests of the people. . . . Is it too much then, that the place and its appendages are beyond the requirements of private station?"[5]

During the Civil War, when funds were needed for the war effort, First Lady Mary Todd Lincoln also was criticized for extravagant spending on the White House. After much of her refurbishing was completed, a San Francisco newspaper offered a somewhat less than sparkling compliment in 1862: "The President's house has once more assumed the appearance of comfort and comparative beauty."[6]

In 1902, early in the second century of White House occupancy, President Theodore Roosevelt gave a completely new tone to the White House. In a major renovation, accompanied by significant sales of old furnishings, the public rooms of the White House became more historic in nature, evoking the period of the house's earliest occupancy. As the nostalgia of the Centennial Exposition in Philadelphia in 1876 and the classicism of the Columbian Exposition in Chicago in 1893 helped promote a new appreciation for the styles of an earlier America, President Roosevelt became a proponent of the Colonial Revival. In 1902, he hired the noted New York architects McKim, Mead & White to make the interior of the White House more stylistically compatible with its late eighteenth-century architecture. By sweeping out the Victorian decorations that had "yielded to the passing fancy of the day instead of having an organic relationship with the building,"[7] the White House would no longer reflect the currents of contemporary style, ending a century of being treated as a modern home. Even though those interior decorations of 1902 revived furnishing styles spanning about 150 years, President Roosevelt wrote that the

White House had been "restored to the beauty, dignity, and simplicity of its original plan."[8]

A quarter century later, in the late 1920s, the collecting of actual period furnishings for the White House was first attempted when First Lady Grace Coolidge secured a small number of "antiques" for placement in the Green Room. Her acquisitions program never flourished, but her successor, Lou Hoover, commissioned a study of all the furnishings of the White House, assigning numbers to objects to help preserve their identities.

The most invasive renovation of the White House took place from 1949 to 1952 under President Harry S. Truman. This was prompted by a need for structural stability that led to a gutting of the old stone-clad shell in order to excavate basements and erect a steel frame around which to rebuild and modernize. Some older furniture was restored. A large quantity of new furniture, many pieces adapted from early nineteenth-century styles, was acquired. The Colonial Revival of half a century earlier had become more mainstream in American design for household furnishings.

In 1960, First Lady Mamie Eisenhower approved the assembly of a small collection of antiques with which to furnish the Diplomatic Reception Room, but it remained for her successor, Jacqueline Kennedy, to pursue successfully the same goal of making all the public rooms equally impressive. Mrs. Kennedy envisioned the very visible, symbolic, and highly visited White House as an ideal showcase of American fine and decorative arts for the enjoyment and education of both American and foreign visitors. Congress passed a law requiring that the museum character of the public rooms must be maintained in perpetuity. Mrs. Kennedy brought in the first curator to supervise the creation of a museum collection and worked with an advisory body that formally became the Committee for the Preservation of the White House in 1964. She then appealed to the American people to donate objects or the money with which antiques could be purchased. Her efforts at the White House were influential in increasing popular interest in art and antiques and in historic preservation. Each subsequent first lady has contributed to these acquisition and preservation efforts.

Jacqueline Kennedy also fostered the creation of the White House Historical Association in 1961. Originally conceived to publish a guidebook about the White House, the association has grown into an essential cooperating

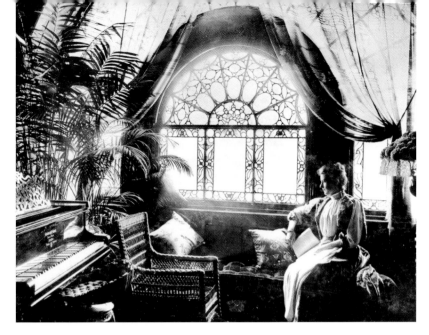

**FRANCES CLEVELAND** *in the West Sitting Hall, 1893,*
*photograph by Frances Benjamin Johnston. Library of Congress*

association for the educational and preservation programs of the White House. Over the fifty years since its founding, the association has funded the acquisition of objects for the permanent White House collection, the conservation and interpretation of those objects, the refurbishing of the historic interiors of the public rooms, and exhibits and symposia about White House history. In this exhibit we celebrate this half-century partnership.

In 1962, not long after the founding of the White House Historical Association, President John F. Kennedy spoke of the impact of the White House:

> *Of course I think anyone who comes to the White House as a President desires the best*
> *for his country, but I think he does receive stimulus from the knowledge of living in close*
> *proximity to the people who seem legendary but who actually were alive and who were*
> *in these rooms. . . . Anything which dramatizes the great story of the United States—as*
> *I think the White House does—is worthy of the closest attention and respect by Americans*
> *who live here and who visit here and who are part of our citizenry.*[9]

The White House will continue to evolve—its history, its interiors, its collection. As new first families arrive to put their stamp on this most symbolic building, they will no doubt share the sentiment expressed in 1889 by First Lady Frances Cleveland: "It is to me the most beautiful house in the world. . . . It is not only the beauty of the old house that I love, but I have a feeling of reverence for its past."[10]

# SELECTED OBJECTS FROM THE EXHIBITION

PRESIDENT GEORGE WASHINGTON met Irish-born architect James Hoban in Charleston, South Carolina, in 1791. The next year, this "practical architect" was summoned to confer with Washington on a design for the President's House in the new capital city of Washington. Winning the public design competition in 1792, Hoban was entrusted with building the stone structure that the president wanted to compare favorably with the "first buildings of Europe."[11] In 1798, the exterior stone was whitewashed, giving it a sealing coat that by about 1802 had engendered the nickname, "The White House."

Hoban's building skills appear to have been superior to his cabinetmaking skills, as suggested by the somewhat curious design and construction of this desk, which, by family tradition, he made from mahogany left over from the White House construction at about the time that President John Adams moved in as the first occupant in November 1800. Hoban's work at the White House, however, was not finished. Having settled in Washington, he was recalled by President James Madison in 1815 to rebuild a White House that had been badly damaged when burned by British forces in the War of 1812. By adding the North and South Porticos in the 1820s, he completed his long service to the famous building for which he is rightly most renowned.

**DESK,** *mahogany, c. 1800, attributed to James Hoban (c. 1758–1831), Washington, D.C. Gift of James Hoban Alexander, 1974*

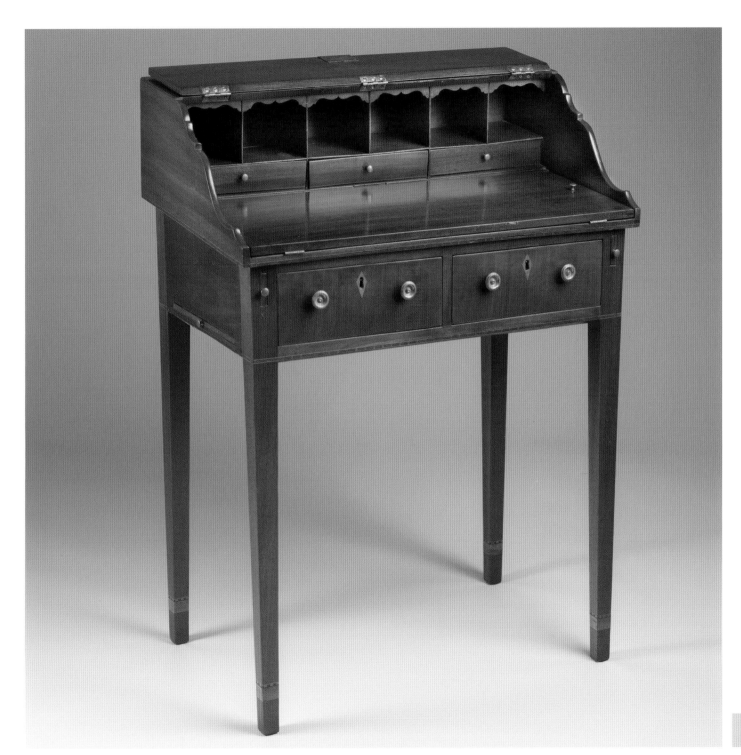

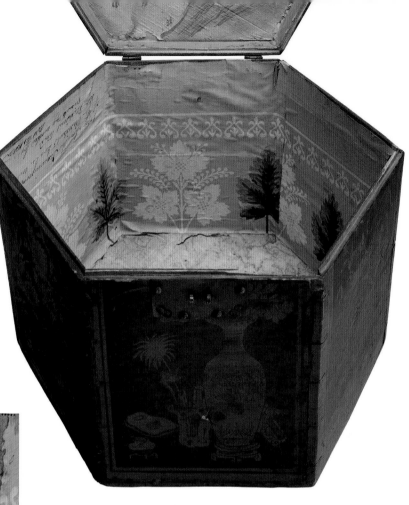

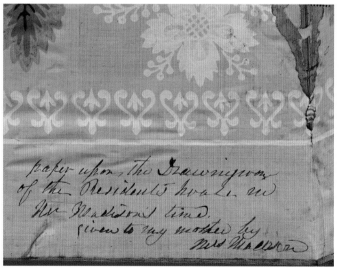

paper upon the Drawingroom
of the Presidents house in
Mr Madisons time.
given to my mother by
Mrs Madison

**WALLPAPER** (detail, left), block-printed paper, c. 1809–11,
made by Jacquemart et Bénard, Paris,
lining a painted wood box (above), c. 1811, China.
Gift of the White House Acquisition Fund, 1971

IN AUGUST 1814, toward the end of the War of 1812, British forces defeated an American army outside Washington, D.C., entered the capital city, and set fire to the principal public buildings, including the White House. Before fleeing the city, First Lady Dolley Madison famously saved the standing portrait of George Washington by Gilbert Stuart (now in the East Room). Most of the other contents of the house, including furniture designed for the "elliptical parlor" (now the Blue Room) by architect Benjamin Henry Latrobe, were destroyed in the fire of August 24.

On December 3, 1814, Mrs. Madison wrote to her friend, Mary Latrobe, wife of the architect:

> Two hours before the enemy entered the city, I left the house where Mr. Latrobe's elegant taste had been justly admired, and where you and I had so often wandered together; and on that very day I sent out the silver (nearly all) and velvet curtains and General Washington's picture, the Cabinet Papers, a few books, and the small clock—left everything else belonging to the public, our own valuable stores of every description, a part of my clothes, and all my servants' clothes, etc., etc.[12]

One artifact of the pre-fire appearance of the interior of the White House has survived due to Mrs. Madison's friendship with Mary Latrobe. Lining a Chinese box is a pink-ground French wallpaper, of a design registered by Jacquemart et Bénard in 1798, that was inscribed in two places by Julia Latrobe, the daughter of Benjamin Henry and Mary Latrobe. One inscription reads: "paper upon the Drawing room of the President's house in Mr Madison's time given to my mother by / Mrs Madison"; the other similar inscription attributes the paper to "the drawing room." The box descended in the Latrobe family until purchased for the White House collection in 1971.

IN THE EARLY NINETEENTH CENTURY, European manufacturers capitalized on the market in the United States for furnishings decorated with national symbols. The most common was the American eagle, as derived from the Great Seal of the United States, but likenesses of the presidents and occasionally even an image of the White House were also used. Not every piece so ornamented, whether made in Europe or America, was commissioned by or purchased for the federal government; but some White House furniture was specially carved with the shield of the United States and official services of china and glassware were usually designed with an eagle or, in later years, the Presidential Coat of Arms.

One of the most popular images of the White House in the nineteenth century was an engraving published in London in 1831. It quickly became one of the "very elegant American views" transfer-printed onto tableware by the Staffordshire potters Job & John Jackson, a shipment of which was received in New York for sale to an eager American market within three months of the publication of the print. This "Jackson Warranted" plate was donated to the White House in 1961, to demonstrate the long-standing public interest in the building and its occupants. The same 1831 print was the basis for the engraving on a Bohemian ruby-stained goblet added to the permanent collection in 1993 as a gift of the White House Historical Association.

**GOBLET** (*opposite, left*), *ruby-stained glass, c. 1840–60, Bohemia. Gift of the White House Historical Association, 1993*

**PLATE** (*opposite, right*), *transfer-printed earthenware, 1831–43?, made by Job & John Jackson, Burslem, England. Gift of Mrs. Harry M. Ullman, 1961*

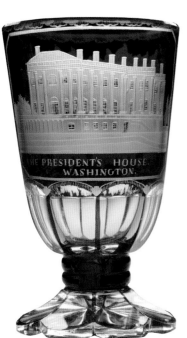

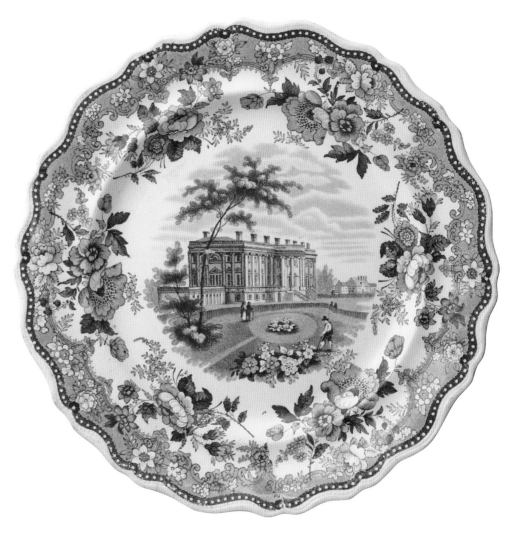

Some early nineteenth-century furnishings imported to the United States were ornamented with the likenesses of early American presidents. As "The Father of His Country," George Washington was the president most frequently represented, sometimes shown in his general's uniform, other times in a civilian suit as the first president. In the aftermath of the War of 1812, Louis Mallet, clocksmith to the Duke of Orléans (later King Louis Philippe of France), made the movement for this small clock with a standing figure of General Washington, a form used by several different French smiths of the time. Beneath the dial appears the famous accolade offered by General Henry "Light-Horse Harry" Lee in his 1799 funeral oration for Washington: "First in war, first in peace, and first in the hearts of his countrymen,"[13] This clock was donated to the White House in 1960, when the National Society of Interior Designers assembled a small collection of antiques to furnish the Diplomatic Reception Room for First Lady Mamie Eisenhower.

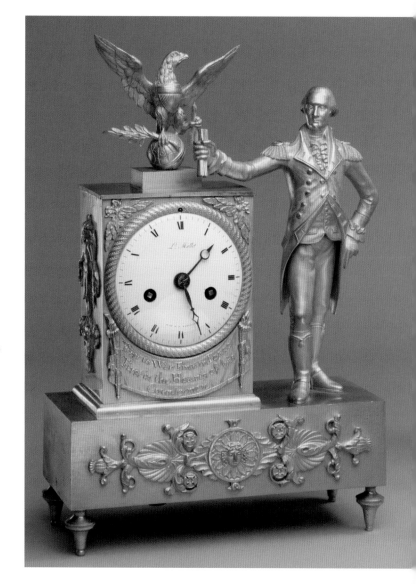

Andrew Jackson's fame as a military hero contributed to his election to the presidency in 1828. Prints made from a portrait of Jackson in uniform by John Vanderlyn, c. 1819, were the source of the image hand-painted on this slim French neoclassical vase made for the American market. This vase was acquired for the White House in 1979 to expand the presidential portrait collection beyond the traditional paintings and sculpture.

**VASE** *(left), porcelain, c. 1825–30, France.*
*Gift of the White House Acquisition Fund, 1979*

**MANTEL CLOCK** *(opposite), gilded bronze,*
*c. 1816, works by Louis Mallet, Paris.*
*Gift of the National Society of Interior Designers, 1960*

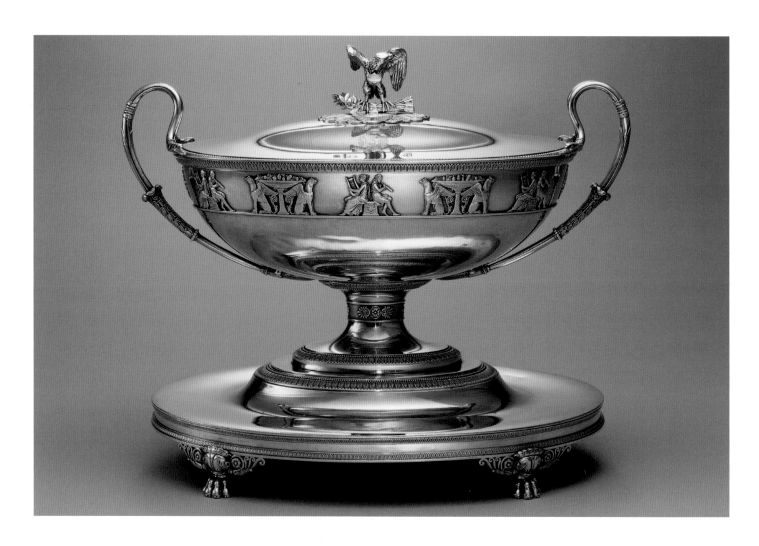

NEARLY ALL OF THE HOUSEHOLD EFFECTS acquired by the first three occupants of the White House—John Adams, Thomas Jefferson, and James Madison—were destroyed when the British burned the residence in 1814. Rebuilt by 1817, the White House was refurnished by President James Monroe, who dramatized his presidency and an American sense of triumph after the War of 1812 through elegant imported furnishings. Among the Monroe acquisitions is a pair of French Empire soup tureens, superb examples of the period's neoclassicism, which contributed to the elegance of White House dinners, especially when customized with American eagle finials.

**SOUP TUREEN,** *one of a pair, silver, c. 1809–17, made by Jacques-Henri Fauconnier (1779–1839), Paris. U.S. Government purchase, 1817*

An auction of old White House furnishings in 1833 produced the funds needed for President Andrew Jackson to acquire a 464-piece service of French Empire table silver. This elegant tableware, made in the period 1809–19, was acquired secondhand from the estate of a former Russian minister to the United States, known as the Baron de Tuyll. Little of the flatware has survived; most was possibly melted down in 1894 to make the gilded dinner and breakfast forks still in use today. But almost all of the holloware, mostly from the vast Paris shop of Martin-Guillaume Biennais, Napoleon's favorite silver producer, remains in the White House collection. Jackson's critics in Congress attacked this expenditure, but the survival of the service, engraved with the traditional "President's House," is a testament to its quality and the value of the investment.

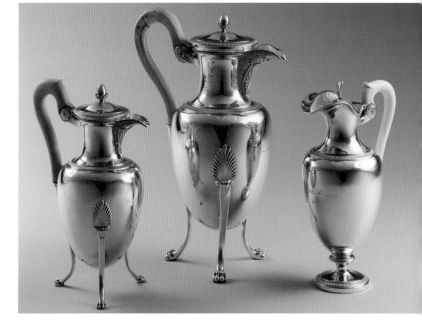

**COFFEEPOTS AND CREAM JUG,** *silver, 1809–19, made by Martin-Guillaume Biennais (1764–1843), Paris. U.S. Government purchase, 1833*

As the rebuilt post-fire President's House came to symbolize the presidency of a strong and united country after the War of 1812, President James Monroe sought to provide a dignity and grandeur to its interiors, writing, "The furniture in its kind and extent is thought to be an object, not less deserving attention than the building for which it is intended."[14] Having spent many years as a diplomat in France, Monroe commissioned agents in 1817 to anonymously buy furnishings in Paris, which was then the principal center of decorative arts in the world and the source for most of the European royal houses. In a letter to Monroe the agent reiterated that he was to obtain articles that "united strength with elegance of form, and combining at the same time simplicity of ornament with the richness suitable to the decoration of a house occupied by the first Magistrate of a free Nation."[15]

Although Monroe had ordered a mahogany suite for the Oval Room (now the Blue Room), he received a fifty-three-piece suite of gilded beechwood furniture made by Pierre-Antoine Bellangé, referred to by the agent as the "first Ebeniste [cabinetmaker] in Paris."[16] The suite included a pier table, two sofas with frames curved to accommodate the room, and thirty-eight chairs. Although the room had fewer doors than today, and thus more wall space, it still must have been a massive amount of furniture, some of which was soon placed in the adjacent Green Room.

In justifying the French purchases, Monroe's aide William Lee wrote that the pieces were of the "very first quality, and so substantial that some of them will last and be handsome for 20 years or more."[17] Little did Lee know that the Bellangé suite would remain in the room for forty-three years, until it was replaced in 1860 with a Rococo Revival suite, and that some of it would return to the room in the 1960s and 1970s, remaining in service today. When the White House was given this first original chair in 1961, First Lady Jacqueline Kennedy had eleven reproductions—seven armchairs and four side chairs—made to fill out the Blue Room. Since then seven additional original pieces—three armchairs, two side chairs, one bergère, and one sofa—have been added to the Blue Room as donations to the White House collection.

**ARMCHAIR**, *gilded beechwood, 1817, made by Pierre-Antoine Bellangé (1758–1827), Paris. Gift of Catherine Bohlen, 1961*

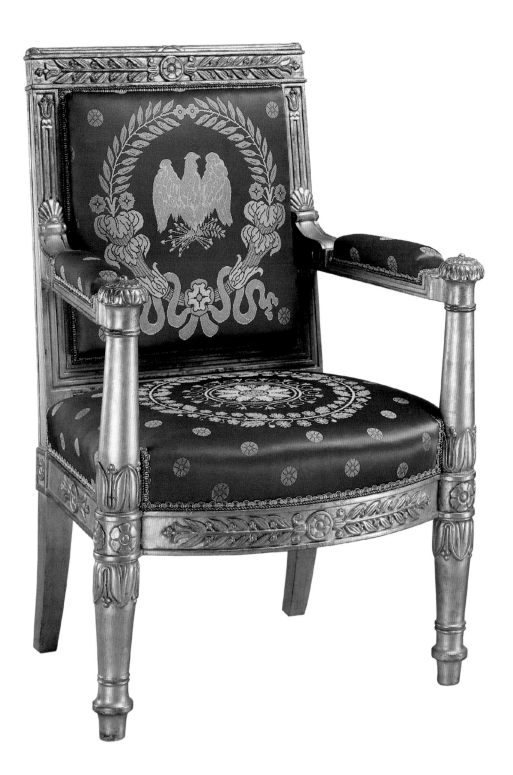

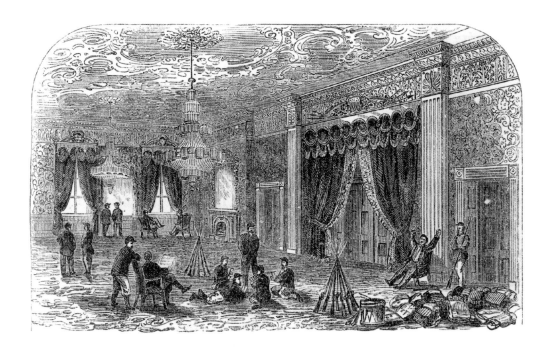

**EAST ROOM,** *Federal troops on duty in 1861 early during the Civil War.*

THE EAST ROOM, called the "Audience Chamber" on architect James Hoban's 1792 plan for the President's House, was not completed during the opening decades of White House occupancy. In 1800 First Lady Abigail Adams famously hung out her wash to dry there, the largest room in the house, a space that was still unfinished when the White House was burned in 1814.

In the post-fire restoration, funding again ran short before the East Room could be completed, but in 1818, President James Monroe acquired a suite of substantial mahogany seat furniture for the room. Twenty-four armchairs and four matching sofas were made locally by William King Jr. of Georgetown, probably the most famous cabinetmaker in the District of Columbia, in no small part due to this patronage by the White House.

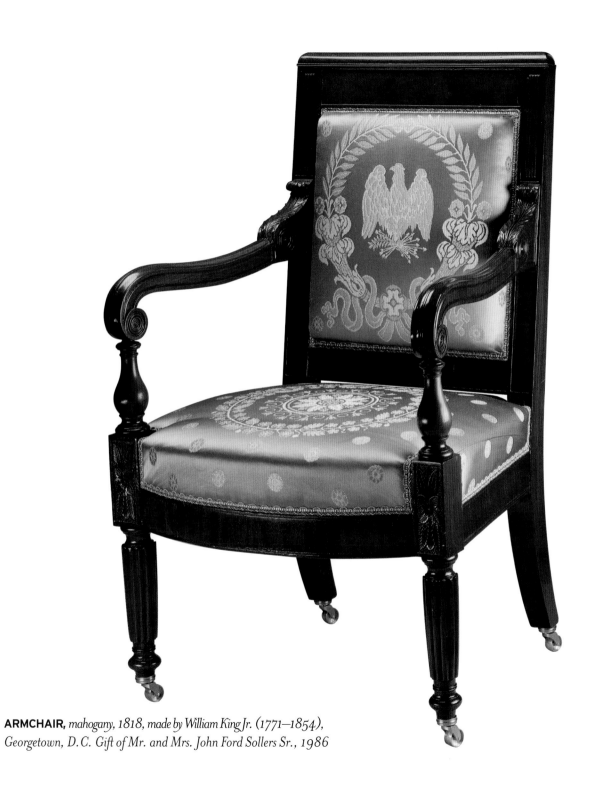

**ARMCHAIR,** *mahogany, 1818, made by William King Jr. (1771–1854),*
*Georgetown, D.C. Gift of Mr. and Mrs. John Ford Sollers Sr., 1986*

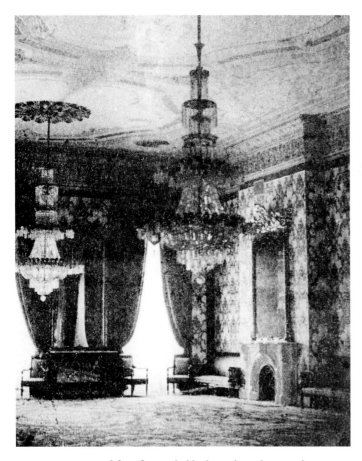

**EAST ROOM,** *c. 1862–67, probably the earliest photograph showing the interior of the White House*

THE 1818 KING SUITE of furniture sat without ornamental show upholstery until 1829, when incoming President Andrew Jackson directed that the funds appropriated for the care of the White House at the start of his term be spent on completing the East Room. The Monroe seating then was upholstered in blue damask with matching draperies, complemented by lemon yellow wallpaper, blue and yellow carpeting, and gilded overmantel mirrors.

Tables were provided by the Philadelphia cabinetmaker Anthony Quervelle, a French emigrant who became one of the great makers of American furniture in the late Empire style. Three circular tables, all extant in the White House collection, were placed under the chandeliers, and four large pier tables were scaled to fit the great piers between the windows at the north and south ends of the room. Only one pier table, bearing Quervelle's paper label, has survived; extensively restored, it bears microscopic evidence indicating that it was once more highly decorated.

The King suite of seat furniture remained in the East Room until 1873 and was probably sold at the famous auction of "decayed property" in 1882 during the Chester Arthur administration. At least six pieces were purchased by John T. Ford, onetime owner of Ford's Theatre in Washington, for his theater in Baltimore. Ford descendants returned one chair (p. 29) to its original home in 1986.

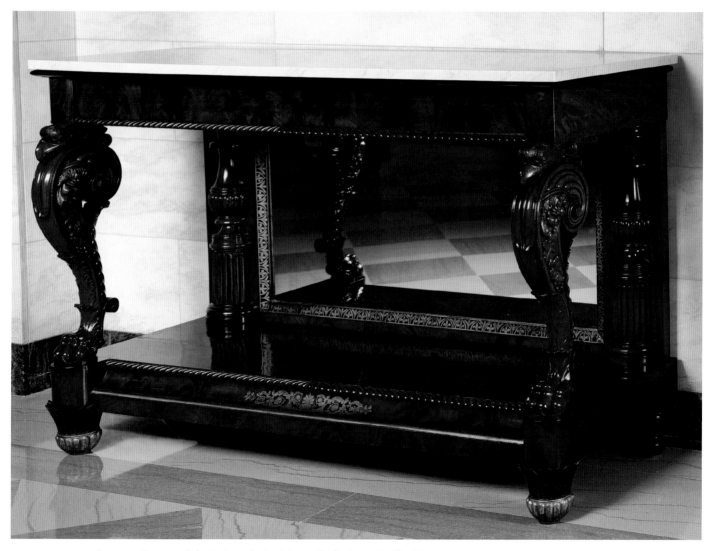

**PIER TABLE**, *mahogany, 1829, made by Anthony Gabriel Quervelle (1789–1856), Philadelphia. U.S. Government purchase, 1829*

One of the most essential functions of the President's House has been as a graceful and prestigious venue for entertaining. First families have long understood the power of food and drink to grease the wheels of political goodwill and diplomacy, and thus in the nineteenth century they routinely dedicated large portions of their congressionally appropriated furnishings budget to properly outfit the State Dining Room. When President James Monroe refurbished the White House following its burning in 1814, he secured French furnishings for the State Dining Room and the Oval Room (now the Blue Room) as the two most important entertaining spaces in the building.

The most expensive item in Monroe's order was a dramatic and exceptionally well crafted table decoration called a plateau, consisting of seven mirrored platforms surrounded by a gilded bronze balustrade. More than 14 feet in length, the plateau arrived with a number of decorative accessories including classical female figures to hold candles and small urns, both of which fit into the balustrade, along with three separate baskets, two urns, and two tripod stands, all of which could be used to hold flowers or fruit. Fashionable in Europe but rarely seen in the United States, the plateau was almost always mentioned in the accounts of Americans who dined at the President's House in the early nineteenth century. In 1818, New York Congressman Thomas Hill Hubbard wrote to his wife: "The plateau was the most elegant thing that I ever saw."[18]

**STATE DINING ROOM** (*opposite, top*), *table set with the Monroe plateau at the State Dinner for the Joint High Commissioners, 1871*

**PLATEAU** (*opposite, bottom*), *gilded bronze and mirror glass, c. 1817, made by Denière et Matelin, Paris. U.S. Government purchase, 1817*

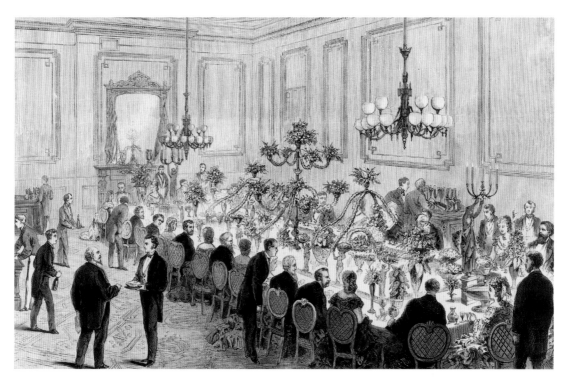

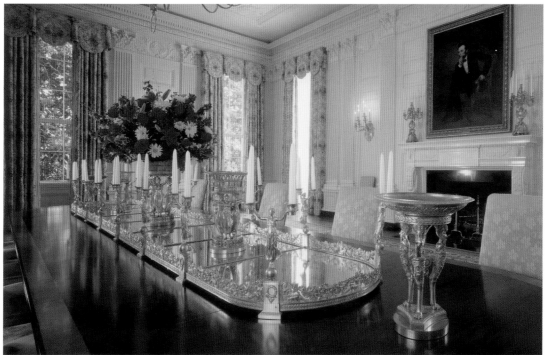

**GREEN ROOM,** *1881–84, the "Hiawatha Boat" decorated with flowers*

THE MONROE PLATEAU DAZZLED GUESTS as the principal table ornament in the State Dining Room for decades, as first families and their staffs created novel displays through the use of accessories and embellishments. In 1876, First Lady Julia Grant selected another bold centerpiece for the president's table at the Centennial Exposition held in Philadelphia. Inspired by Henry Wadsworth Longfellow's poem "The Song of Hiawatha," Gorham Manufacturing Company created a silver sculpture of Hiawatha steering a masted canoe atop a lake of mirror glass. Embracing the Victorian aesthetic of abundance, the "Hiawatha Boat" was often displayed on top of the Monroe plateau and decorated lavishly. For her first State Dinner, First Lady Frances Cleveland had the boat decorated with "red and white camellias, the sails trimmed with smilax. This stood on the large mirror which was bordered with rosebuds, tulips and camellias."[19] The boat, either decorated with flowers or left unadorned, was also used as a table centerpiece in the public parlors.

**CENTERPIECE** *(opposite), silver, 1871, made by Gorham Manufacturing Company, Providence, Rhode Island. Possibly a gift from Gorham Manufacturing Company, c. 1876*

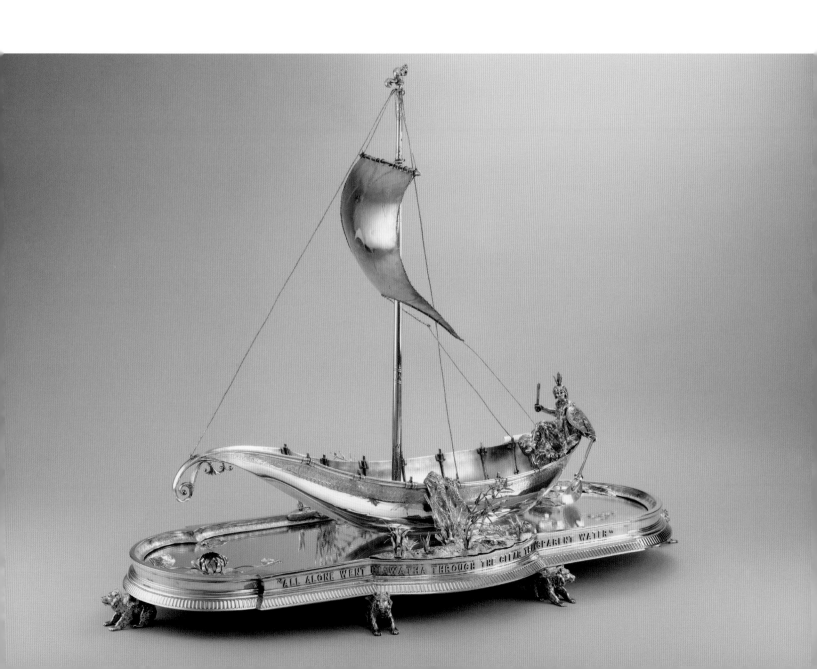

Fashionable china and glass services, often customized with national symbols such as the eagle emblem from the Great Seal of the United States, were purchased as needed to properly outfit the president's table. At New York City's World Fair in 1853, Haughwout & Dailey, a New York china firm, presented two designs for presidential dinner services to President Franklin Pierce. The president selected the cobalt blue and gold service featuring a shield at the center, although he declined Haughwout & Dailey's offer to personalize the service with the addition of a letter *P* in the shields. The only piece from the Pierce service to remain continuously in the White House is a remarkable centerpiece featuring

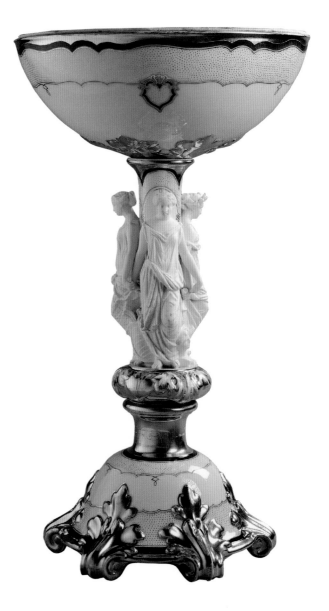

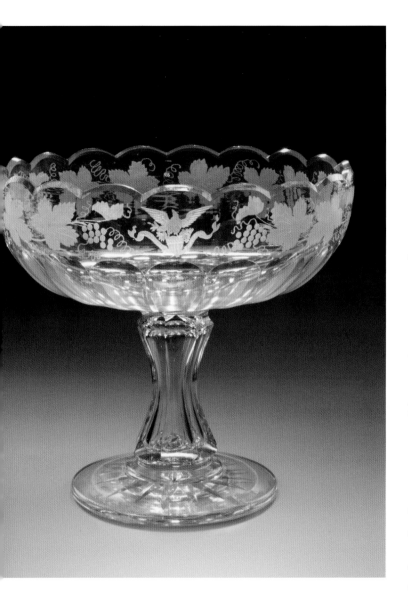

three unglazed allegorical figures (representing Love, Peace, and Abundance) supporting a large bowl at top. The Pierces also probably purchased the beautifully cut and engraved glass service featuring the eagle emblem, many pieces of which survive in the White House collection. This service was long believed to have been the glass service ordered by President Andrew Jackson in 1829, but new scholarship suggests that it cannot date prior to the early 1850s.[20]

**COMPOTE** (*left*), *cut and engraved glass, c. 1853, probably New York. U.S. Government purchase, c. 1853*

**CENTERPIECE** (*opposite*), *porcelain and Parian ware, 1853, decorated by Haughwout & Dailey, New York, on French or English blank. U.S. Government purchase, 1853*

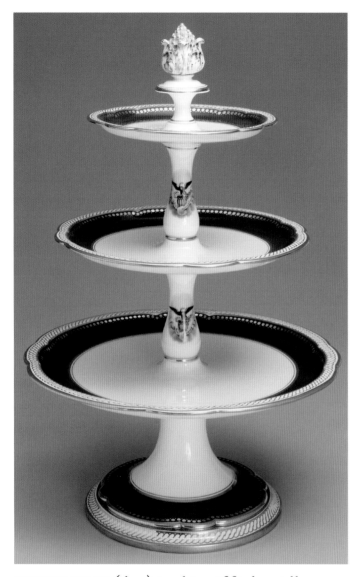

**DESSERT STAND** (*above*)*, porcelain, c. 1861, decorated by E. V. Haughwout & Company, New York, on Sevrès blank. U.S. Government purchase, 1861*

**DINNER PLATTER** (*opposite*)*, porcelain, 1880, made by Haviland & Company, Limoges, France. U.S. Government purchase, 1880*

EIGHT YEARS AFTER PRESIDENT FRANKLIN PIERCE attended the World's Fair in New York, First Lady Mary Todd Lincoln visited E. V. Haughwout & Company, successor to Haughwout & Dailey, and selected the china pattern that Pierce had not chosen in 1853. This design featured a modified version of the arms of the United States at the center and a gold cable pattern known as "Alhambra" at its border. Mrs. Lincoln requested that Haughwout change the originally suggested blue border for a newly fashionable purplish-red color known as solferino. This Lincoln china proved very popular and was reordered often in future administrations.

In 1879, First Lady Lucy Hayes directed the creation of the White House's most distinctive and elaborate state service. She engaged American artist Theodore Davis to design a service based on American flora and fauna. Davis created twelve different images for each of the five courses in addition to images for the different types of serving dishes, resulting in the service containing more than 130 unique designs.

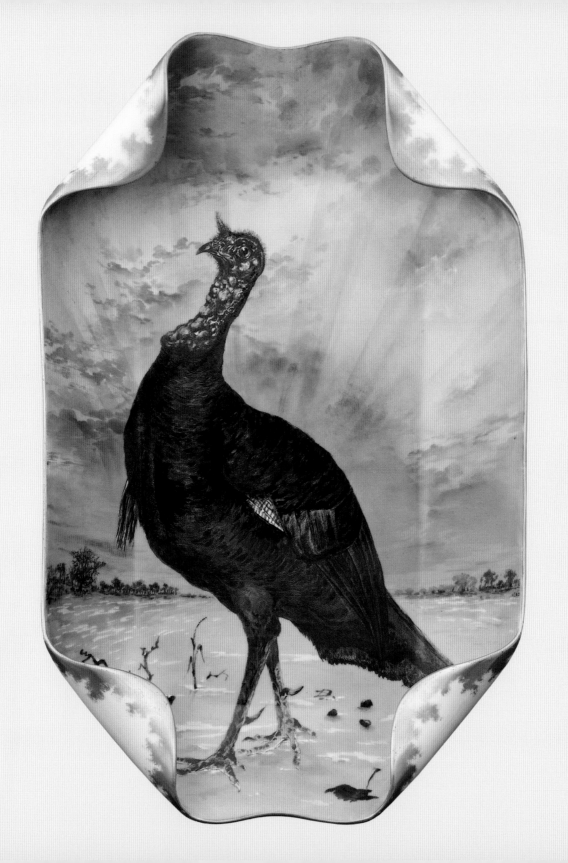

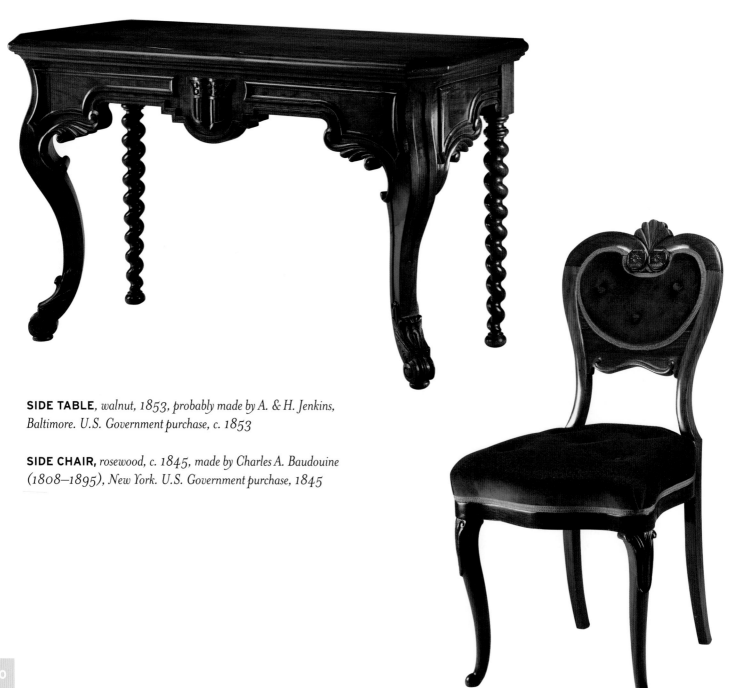

**SIDE TABLE**, *walnut, 1853, probably made by A. & H. Jenkins, Baltimore. U.S. Government purchase, c. 1853*

**SIDE CHAIR,** *rosewood, c. 1845, made by Charles A. Baudouine (1808–1895), New York. U.S. Government purchase, 1845*

Unlike the primarily European-made tableware and ornaments used in the President's House dining room during the nineteenth century, the furniture was of domestic manufacture in accordance with an 1826 act of Congress. In 1845, President James K. Polk purchased a set of forty-two rosewood chairs upholstered in purple velvet for the State Dining Room. These were secured from the New York shop of Charles Baudouine, originally from France, who was known for his fashionable Rococo Revival–style furniture. This table is one of a set of four believed to have been made by A. & H. Jenkins of Baltimore for the State Dining Room in 1853. Like many of the ceramic and glass services used at the President's House, these tables were customized by the addition of a carved United States shield. The tables survived in the dining room even longer than the chairs, not being removed until Theodore Roosevelt's comprehensive redecoration in 1902.

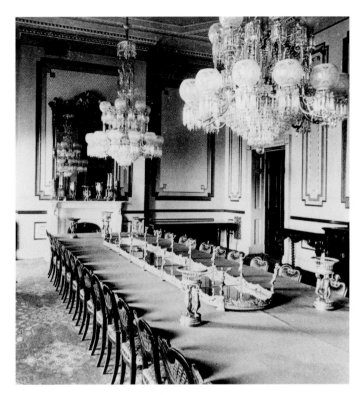

**STATE DINING ROOM,** *c. 1870–77*

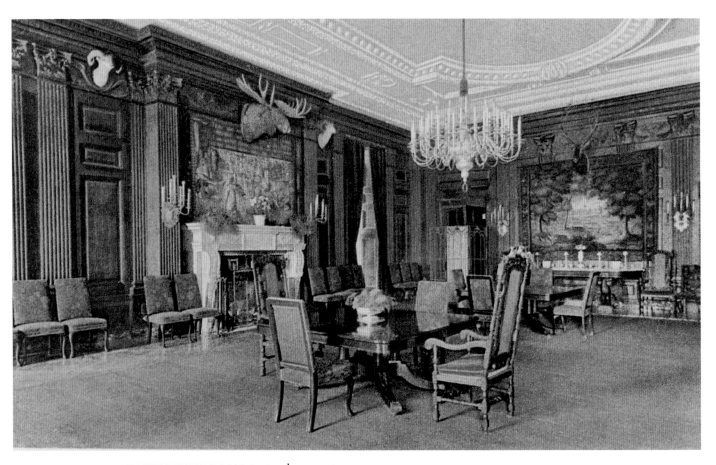

**STATE DINING ROOM,** *postcard, c. 1904*

THE PRESTIGIOUS NEW YORK architectural firm of McKim, Mead & White directed the large-scale renovation of the White House in 1902 under President Theodore Roosevelt. The State Dining Room was enlarged to its current size and furnished in the manner of an eighteenth-century English country house dining room, complete with darkly stained oak wall paneling, tapestries, and mounted animal heads. The mahogany eagle-pedestal side tables and tapestry-upholstered chairs contributed to the rich, manorial character of the room, which reminded one visitor of a German hunting lodge.[21]

A new set of six armchairs in the late seventeenth-century William and Mary style and fifty side chairs in the early eighteenth-century Queen Anne style were provided for the room by the Boston furniture manufacturer A. H. Davenport & Company, based on designs by McKim, Mead & White.

The armchairs originally featured seat cushions of dark green velvet and were used by the principal diners at an event, typically the president and/or the first lady.

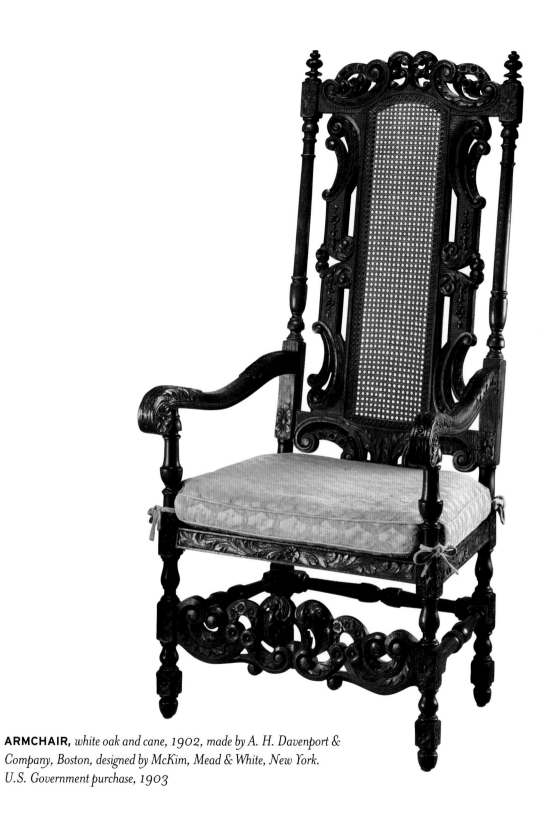

**ARMCHAIR,** *white oak and cane, 1902, made by A. H. Davenport & Company, Boston, designed by McKim, Mead & White, New York. U.S. Government purchase, 1903*

**PRESIDENT THEODORE ROOSEVELT'S BREAKFAST TRAY,** *1903. Library of Congress*

MOST PERIOD IMAGES OF THE WHITE HOUSE show the rooms either "at rest" or during a large social event. This picture of President Theodore Roosevelt's breakfast tray is a rare glimpse into the more intimate side of living in the White House. President Roosevelt typically enjoyed a quiet breakfast with his wife, followed by a walk around the White House grounds, before heading to his office. The president described his morning routine to his son Kermit in a November 1, 1905, letter: "Of course I am up to my ears in work. The mornings are lovely now, crisp and fresh; after breakfast Mother and I walk around the grounds accompanied by Skip [a mixed breed dog who was the president's closest canine companion] and also by Slipper [one of the Roosevelts' cats], her bell tinkling loudly. The gardens are pretty dishevelled now, but the flowers that are left are still lovely; even yet some honeysuckle is blooming on the porch." As he expressed to Kermit in an earlier letter of June 21, 1904, "I don't think that any family has ever enjoyed the White House more than we have."[22]

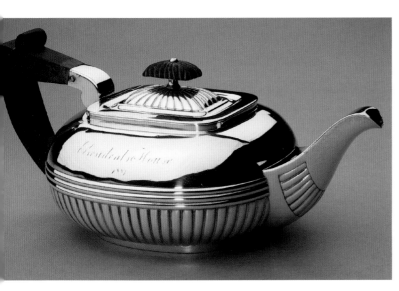

**TEAPOT,** *silver and ebony, 1881, made by Dominick & Haff, New York. U.S. Government purchase, 1881*

**JAR,** *cut glass and silver, c. 1901, American. U.S. Government purchase, c. 1901*

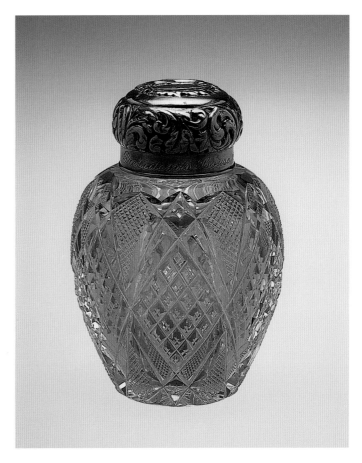

GIVEN IN HONOR OF A HEAD OF STATE or government from another country, the State Dinner has long represented the ultimate White House social event. Traditionally, but not always, held in the State Dining Room, such dinners were usually served at a single large table of various configurations. First Lady Jacqueline Kennedy introduced eating at small circular tables, an arrangement that allows for 130 people to be seated in the room.

Any of the state china services remaining in sufficient quantities may be used for a State Dinner. The dramatic Reagan service with its brilliant red border has proved popular with many subsequent first families. Historic gilded flatware is also typically used at State Dinners. The earliest pieces in this collection were acquired in 1833 by President Andrew Jackson. This flatware was customized with the inscription "President's House" and an engraving of an American eagle. Over the years, replicas or adaptive flatware has been made to supplement the original pieces. In 1924, First Lady Grace Coolidge purchased pearl-handled knives with gold-plated blades to complement the existing gilded flatware. Glassware in a simple, unadorned style has been used at State Dinners since Jacqueline Kennedy selected it for White House dining.

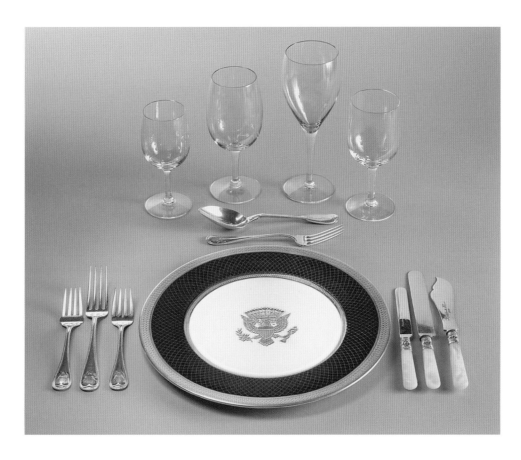

**SERVICE PLATE,** *porcelain, 1982,*
*made by Lenox, Inc., Trenton, New Jersey.*
*Gift of The Knapp Foundation, 1982*

**CHAMPAGNE GLASS,** *1961, made by*
*Morgantown Glass Guild, Morgantown, West Virginia.*
*U.S. Government purchase, 1961*

**WATER GLASS,** *1974, made by Fostoria,*
*Wheeling, West Virginia.*
*U.S. Government purchase, 1974*

**DINNER WINE GLASS, DESSERT WINE GLASS,** *1991,*
*made by Lenox, Inc., Trenton, New Jersey.*
*U.S. Government purchase, 1991*

**DESSERT SPOON,** *gilded silver, 1809—19,*
*made by Pierre-Joseph Dehanne, Paris.*
*U.S. Government purchase, 1833*

**DINNER FORK, DESSERT FORK,** *gilded silver, 1894,*
*made by Durgin Silver Company, Concord, New Hampshire.*
*U.S. Government purchase, 1894*

**DINNER KNIFE,** *gilded silver, 1924,*
*made by American Silver Company, Bristol, Connecticut.*
*U.S. Government purchase, 1924*

**FISH KNIFE, FISH FORK, SALAD FORK,** *gilded silver, 1950,*
*made by S. Kirk & Son, Baltimore.*
*U.S. Government purchase, 1950*

**SALAD KNIFE,** *gilded silver, 1994, made by Kirk Stieff, Baltimore.*
*U.S. Government purchase,1994*

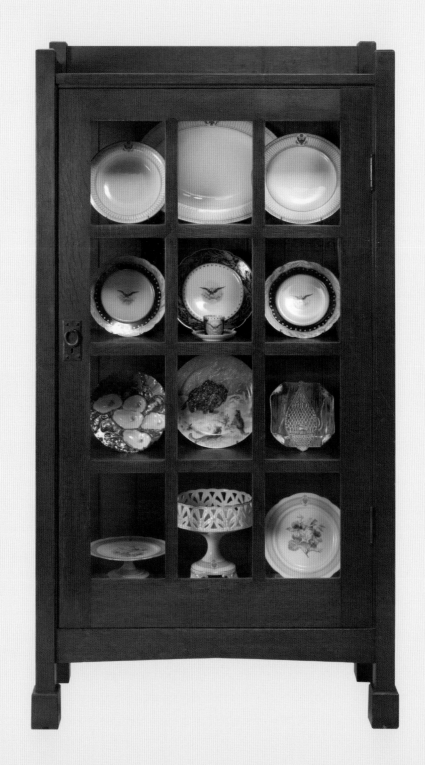

**GROUND FLOOR CORRIDOR** *(above), c. 1904*

**CABINET** *(opposite), white oak, c. 1904,
made by Gustav Stickley (1858–1942), Eastwood, New York.
U.S. Government purchase, 1904*

THROUGHOUT MOST OF THE NINETEENTH CENTURY, White House furnishings were valued for their contemporary style and practicality and not seen as historic objects worthy of preservation. That view began to change following the 1876 Centennial celebration in Philadelphia. First Lady Caroline Harrison took a special interest in White House china that had accumulated over many years and initiated the first attempt to identify and document those tablewares. The journalist Abby Gunn Baker later continued this work with the strong support of first ladies Ida McKinley and Edith Roosevelt. In 1904, Mrs. Roosevelt ordered two oak cabinets in the Arts and Crafts style to display examples of presidential services in the east end of the Ground Floor Corridor. Placed in a high traffic area where guests entering through the new East Wing could easily see them, these cabinets contained the first display of White House furnishings. The china display quickly expanded to four cabinets in the hallway, and in 1917, First Lady Edith Wilson devoted an entire room just off the Ground Floor Corridor to exhibiting presidential tablewares.

The creation of the China Room and the recognition of the value of preserving presidential furnishings inaugurated a new museum function for the White House. With time, a professional curatorial office was established within the White House to care for the collection, which now totals approximately 50,000 objects. Although operating in a nontraditional setting, the White House is today a professionally accredited museum.

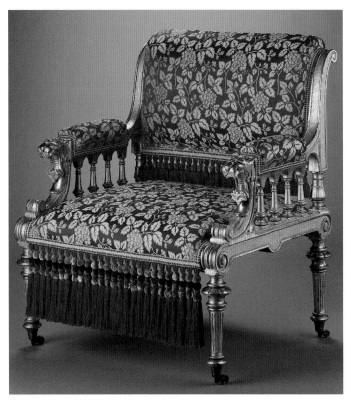

**ARMCHAIR** (above), gilded ash, c. 1875, made by Herter Brothers, New York. U.S. Government purchase, 1875

**RED ROOM** (opposite), c. 1877

IN THE LAST QUARTER OF THE NINETEENTH CENTURY, the White House public rooms reflected modern furnishing fashions, characterized by historic revivals, exoticism, and abundance, an aesthetic now commonly referred to as Victorian. To properly furnish the White House, first families increasingly sought the expertise of the large, comprehensive interior design firms that appeared in this period, creating unified interiors by supplying all necessary components including architectural elements, flooring, wall and ceiling decoration, textiles, and furnishings.

In 1875, First Lady Julia Grant hired the New York company Herter Brothers, one of the earliest and most successful of the American decorating firms, to refurbish the Red Room. The firm supplied new window hangings and thirteen pieces of furniture in the emerging Aesthetic taste. Only two of the items from this order survive at the White House: a beautifully carved and inlaid rosewood center table (p.52) and a gilded armchair, each carved with lion heads.

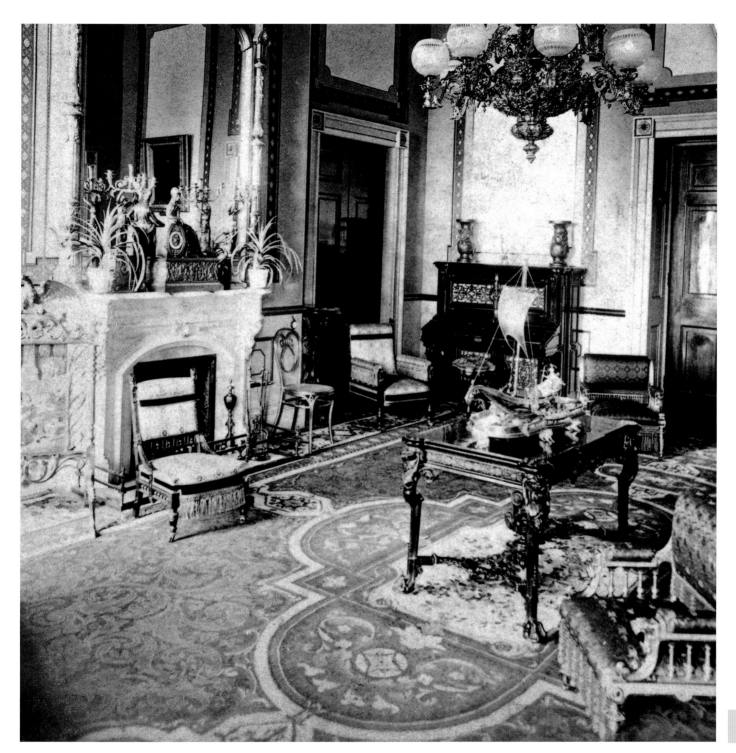

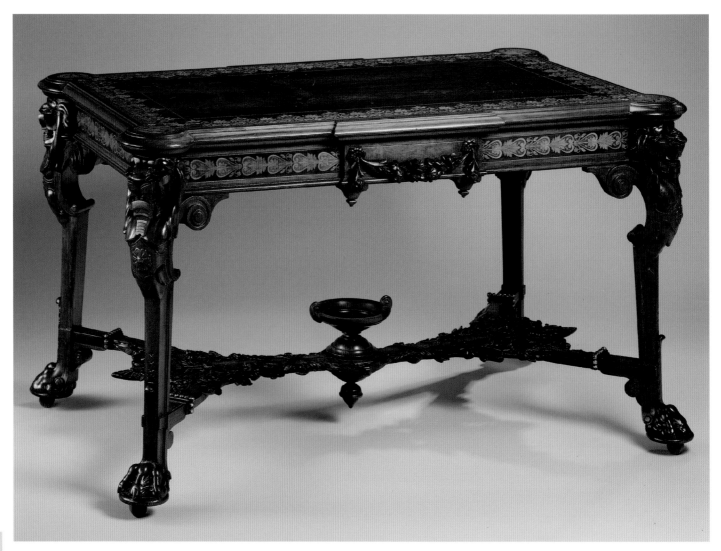

**CENTER TABLE**, *rosewood, c. 1875, made by Herter Brothers, New York. U.S. Government purchase, 1875*

Inspired by the recent opening of Japan to the West, Herter Brothers was an early proponent of incorporating Japanese elements into its designs. In the 1870s and 1880s, Americans eagerly embraced what was known as "the Japan craze," seeking to add exotic furnishings to their interiors. The window hangings that Herter Brothers fashioned for the Red Room were made of "Japanese satin, golden bronze," while one of the "2 all gilt Lady's chairs" was covered in "red and gold Japanese Brocade."[23] This description inspired the reupholstery of the surviving chair (p. 50) in 1999.

An image of the Red Room taken about 1877 (p. 51) documents the display atop the piano of a pair of Japanese bronze urns featuring cast sculptural dragons

**URNS** (right), pair, bronze, c. 1860–67, Japan. Undocumented acquisition by 1867

alongside the Japanese textiles installed by Herter Brothers. These urns had entered the White House collection by 1867, when an official inventory of government property noted, "These vases, it is said, were presented to the President's House . . . considered of great value."[24] It has been assumed that they were the gift of a foreign government, possibly from the first Japanese delegation to visit the White House in 1860. As authentic examples of Japanese craftsmanship and design, the urns contributed to the fashionable and exotic quality of the heavily used reception room.

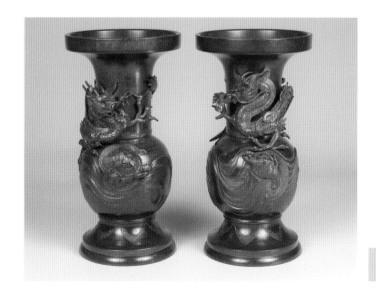

IN 1902, A NEWSPAPER REPORTER WROTE, "Undoubtedly the handsomest bits of bric-a-brac at the White House are the gifts presented by the foreign rulers: the screen sent by the Austrian government during General Grant's occupancy of the White House; the two quaint jars [that] were gifts from the King of Siam; the immense Sevres vases which come as a token from the French government a few years ago, and other like mementoes."[25] In the nineteenth and early twentieth centuries, foreign gifts to a president were often kept for the White House. In modern times, however, gifts presented to the president and first lady, including those from foreign leaders, are sent to the National Archives, where they are held for eventual transfer to that administration's presidential library.

In 1855, upon his return from successfully negotiating the first trade agreement between the United States and Japan, Commodore Matthew Perry met with President Franklin Pierce at the White House and presented him with some of the Japanese goods he had procured there. Three finely crafted lacquer pieces with a long history at the White House are believed to have been among the gifts presented at this time. The three pieces are consistently seen in photographs stacked one on top of another, despite the fact that they never would have been used this way in Japan: a low table topped by a cabinet (known as a *chigai-dana*) topped with a small box. Widely admired, the Japanese pieces were used in both the State Rooms and the private family quarters for most of the century.

**CABINET (*CHIGAI-DANA*)** *(opposite, top), lacquered and gilded wood, c. 1854, Japan. Gift of the Emperor of Japan, 1855*

**BENJAMIN HARRISON FAMILY IN A SECOND FLOOR BEDROOM** *(opposite, bottom), c. 1889. Daughter Mary McKee, with her children, Benjamin and Mary, and daughter-in-law Mary Harrison, with her daughter, Marthena, in front of the* **chigai-dana**

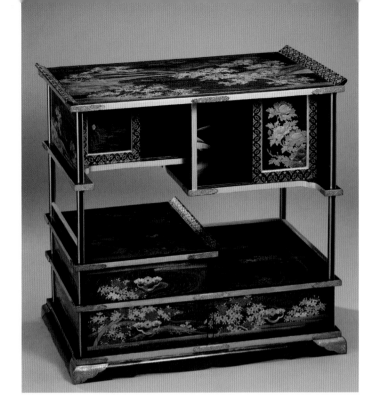

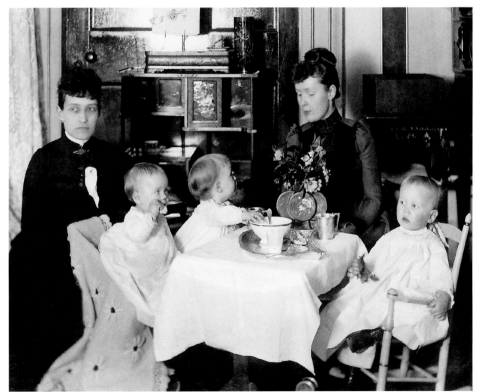

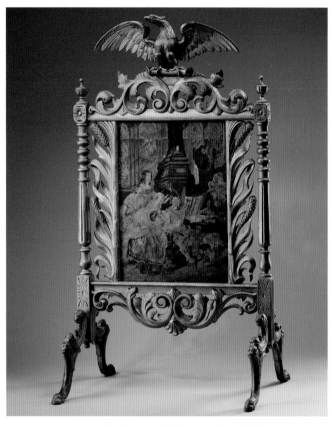

**FIRE SCREEN,** *embroidery and gilded wood, c. 1876,*
*embroidery by Edward A. Richter, Vienna, Austria.*
*Gift of Edward A. Richter, 1877*

IN HONOR OF THE ONE-HUNDREDTH ANNIVERSARY of
the signing of the Declaration of Independence,
Philadelphia was selected to host the Centennial
Exposition in 1876, where craftsmen from around
the world exhibited their masterpieces. Austrian
embroiderer Edward A. Richter decided to give the fire
screen he exhibited at the Centennial to President
Ulysses S. Grant, "only under the condition that they
[textile and frame] have to belong to the furniture of the
Executive Mansion."[26] After spending a quarter century
in the Red Room, the screen was moved to the Green
Room following the Roosevelt renovation of 1902,
joining the *chigai-dana* in that space.

On August 17, 1898, French President Félix Fauré
and President William McKinley exchanged messages on
the first day of operation for a new trans-Atlantic cable
between the two countries. To celebrate this event, Fauré
sent a pair of very large cobalt blue porcelain vases made
at the famed French porcelain factory at Sèvres. Upon
their arrival, the vases were prominently displayed
flanking the central bow window of the Blue Room. In
1902, they were moved to the east wall of the East Room,
where they remained until 1947.

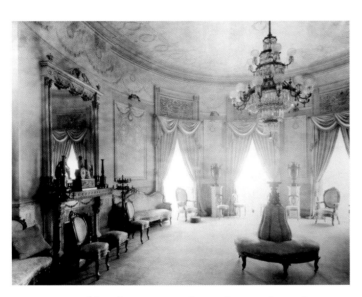

**BLUE ROOM** (*above*), *c. 1900, with vases between the windows*

**VASE** (*right*), *porcelain and gilded metal, 1898,*
*made by the National Porcelain Manufactory of Sèvres, Paris.*
*Gift of the French Republic, 1898*

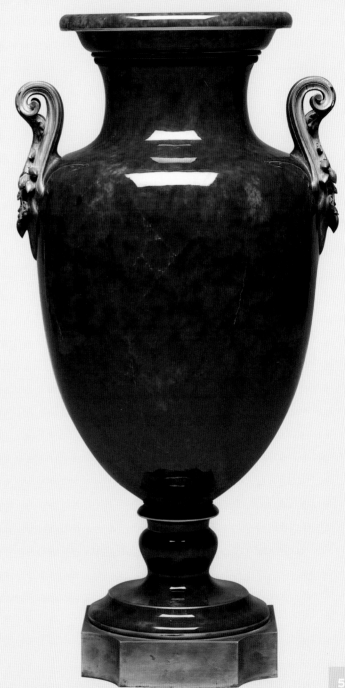

ELECTRICITY WAS FIRST INTRODUCED in the White House in 1891, installed by the Edison General Electric Company. Tentative about the new technology, President Benjamin Harrison and First Lady Caroline Harrison did not want to abandon familiar gaslight, so the majority of the existing gas fixtures were retained and wired so that they could provide both gas and electric light. The Harrisons also refused to touch the electric light switches for fear of getting shocked, and thus relied on staff to turn the lights on and off throughout the house. The Family Dining Room, the smaller of two dining rooms on the State Floor, received all new electric fixtures: four cherub-form sconces and a matching chandelier. In 1902, architects McKim, Mead & White removed all the 1891 fixtures from this room when they abandoned the room's former eclectic and highly decorative furnishing scheme for their spare interpretation of an early American interior. The cherub sconces, however, were deemed acceptable for the Second Floor private quarters and were installed in the West Sitting Hall, where they served for another forty-six years.

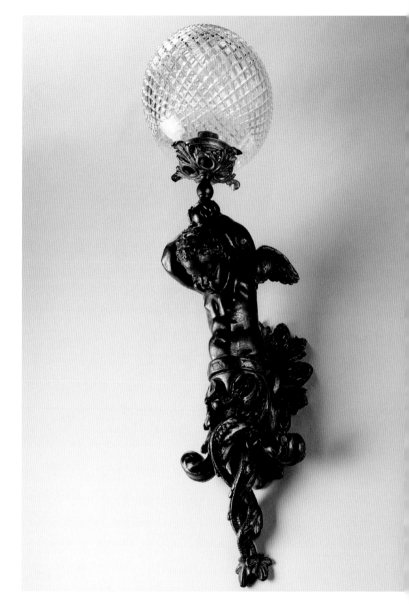

**SCONCE**, *brass and cut glass, c. 1891, American. U.S. Government purchase, 1891*

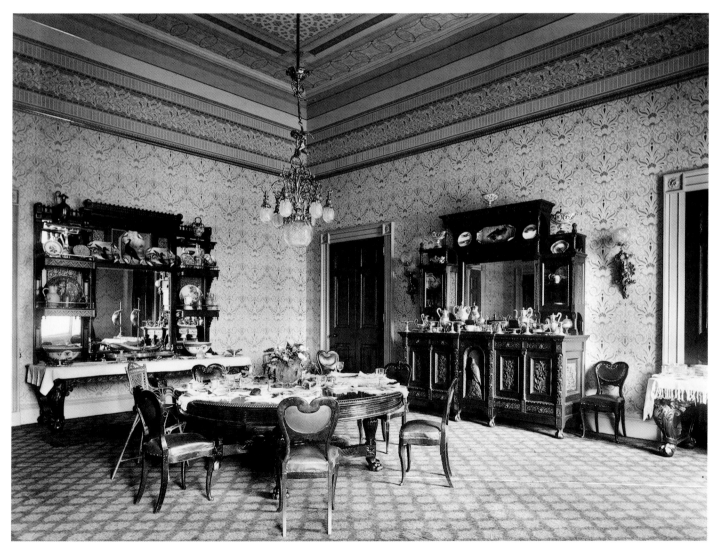

**FAMILY DINING ROOM**, *1893, photograph by Frances Benjamin Johnston. Library of Congress*

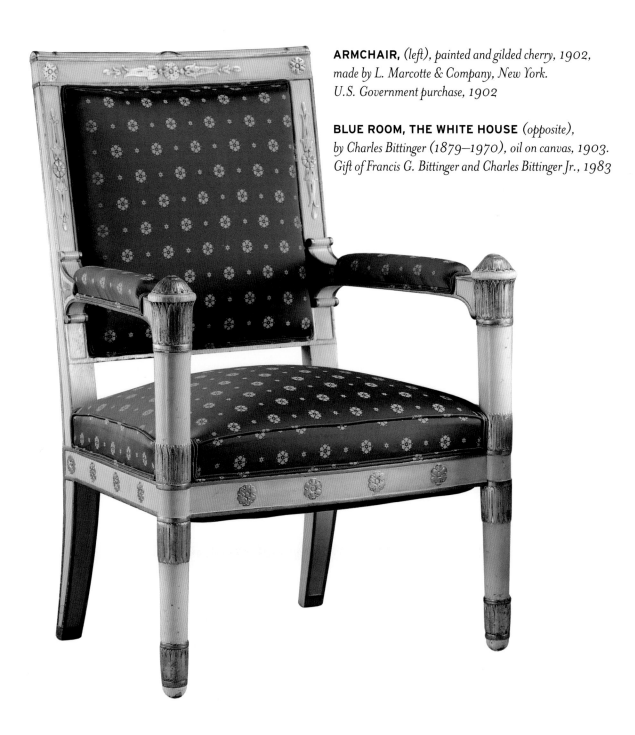

**ARMCHAIR,** *(left), painted and gilded cherry, 1902, made by L. Marcotte & Company, New York. U.S. Government purchase, 1902*

**BLUE ROOM, THE WHITE HOUSE** *(opposite), by Charles Bittinger (1879–1970), oil on canvas, 1903. Gift of Francis G. Bittinger and Charles Bittinger Jr., 1983*

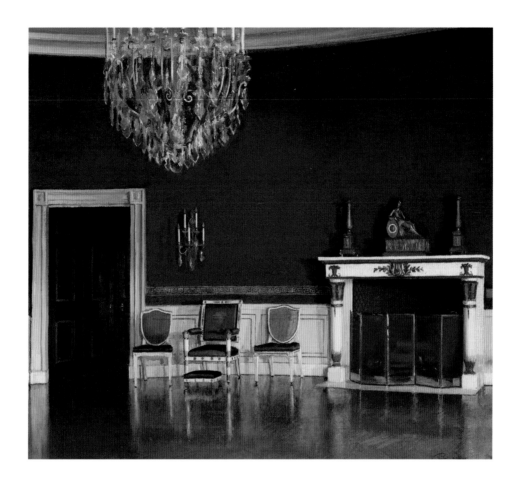

FACED WITH JUST A FEW SHORT MONTHS in 1902 to complete a massive renovation of the White House, McKim, Mead & White divided the interior furnishings contracts among a few leading New York decorating firms. Prior to the renovation, the Blue Room retained the suite of Rococo Revival–style furniture installed in the space in 1860 during the James Buchanan administration. Desiring to return the Blue Room to the French Empire style of President James Monroe's furnishing of the room in 1817, the architects entrusted L. Marcotte & Company, founded by French immigrants and retaining close ties to France, to complete the work. Marcotte took a literal approach to the task, choosing to reproduce a period suite of French furniture: the model was most likely a c. 1809 painted and gilded Empire suite at the Château de Compiègne, one of the French royal residences.

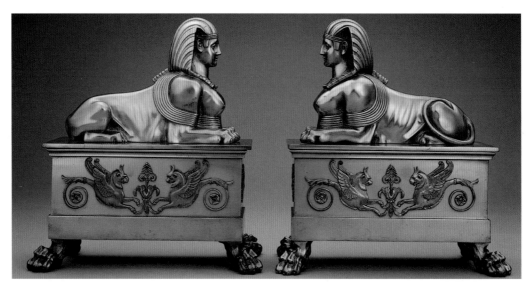

**ANDIRONS,** *brass, c. 1902, France. U.S. Government purchase, 1902*

IN ADDITION TO REPRODUCING a French Empire furniture suite, L. Marcotte & Company also used a period model for the Egyptian Revival–style andirons it supplied for the Blue Room. Despite these careful attempts at period authenticity, Marcotte and his contemporaries found no incongruity in completing the Blue Room's seating furniture with a set of shield-back side chairs inspired by early nineteenth-century English, rather than French, design. These side chairs originally had cane backs; upholstered backs had been substituted by the mid-1920s, probably due to the fragility of cane seating in a heavily used room. Unlike James Monroe's Blue Room furniture suite, which boasted fifty-three total pieces, Marcotte's consisted of twenty-five pieces, giving the room a much sparer appearance. The 1902 Blue Room also lacked a floor covering, increasing its sense of spaciousness. Like the Red and Green Rooms to either side, the Blue Room received a dark fabric wall covering in its appropriate hue.

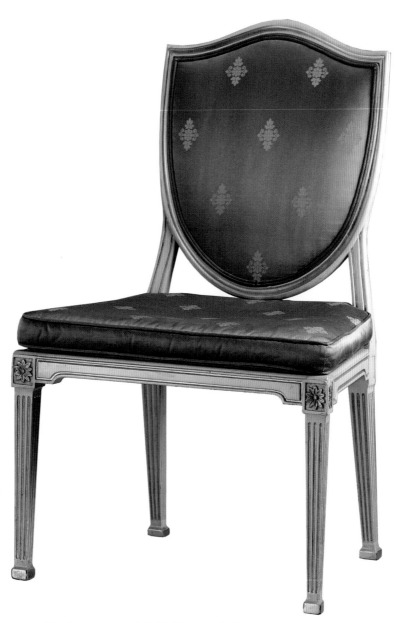

**SIDE CHAIR,** *painted birch, 1902, made by L. Marcotte & Company, New York. U.S. Government purchase, 1902*

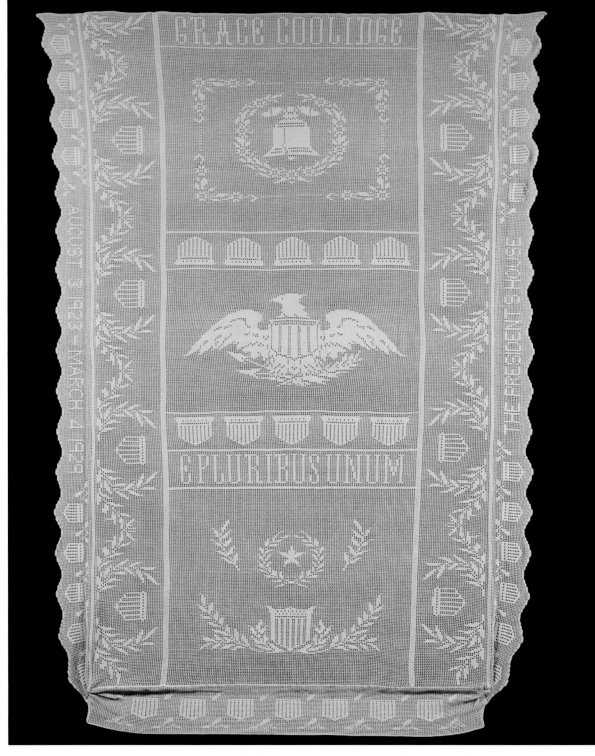

**COVERLET,** *crocheted shoe thread, 1925–27, made by Grace Goodhue Coolidge (1879–1957), Washington, D.C.*
*Gift of Grace Coolidge, 1927*

FIRST LADY GRACE COOLIDGE personally made a coverlet for the famous "Lincoln bed" at the White House, intending it to be a "token which shall go down through the ages to serve as a definite and visible link connecting the present and the past."[27] On one border appears "The President's House," the early nineteenth-century name for the White House. Patriotic decoration includes an American eagle emblem, the national motto "E Pluribus Unum," the Liberty Bell, and an abundance of American shields. Although the piece was completed while she was sailing on the presidential yacht in 1927, she projected the close of her husband's term in the dates "August 3, 1923–March 4, 1929" on the other border. Mrs. Coolidge hoped the coverlet would begin, for first ladies, a tradition of leaving a memento of family life for the White House, but she was the only one to produce such an artifact.

**LINCOLN BED** (*above, and detail below*), *c. 1927, photograph by Ralph W. Magee*

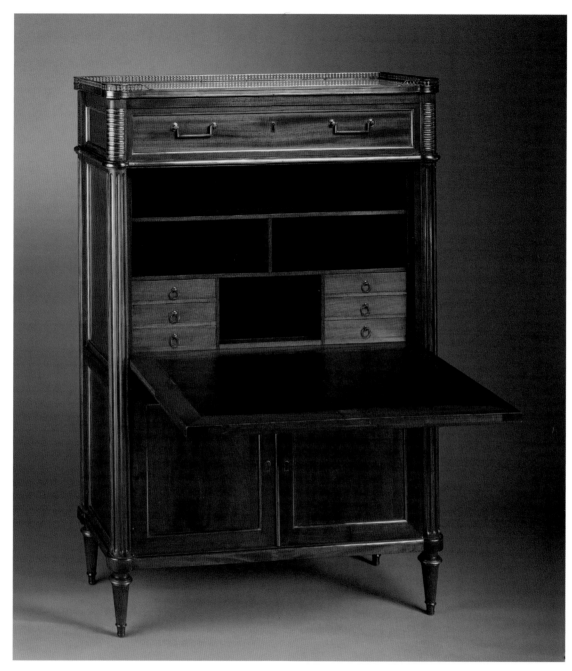

**DESK,** *mahogany, 1932, made by Morris W. Dove (1878–1968), Washington, D.C.*
*U.S. Government purchase, 1932*

After initiating the first thorough study of the furnishings of the White House, First Lady Lou Hoover acknowledged the importance of the post-fire refurnishing by President and Mrs. James Monroe with the creation in 1932 of the "Monroe Room," a sitting room (once the Cabinet Room) in the private quarters. She commissioned reproductions of seven pieces of furniture that had been among the personal furnishings brought by the Monroes to the White House. One was a French fall-front desk (*secrétaire à abattant*) on which President Monroe reportedly signed his 1823 Annual Message to Congress, the section of which concerning European noninterference in the Americas is now called the Monroe Doctrine.

The reproduction pieces were made by the Washington, D.C., cabinetmaker Morris W. Dove, a Russian immigrant with a long association with the White House; when departing cabinet officers received their cabinet chairs by purchase or gift from staff or friends, he made replacements.

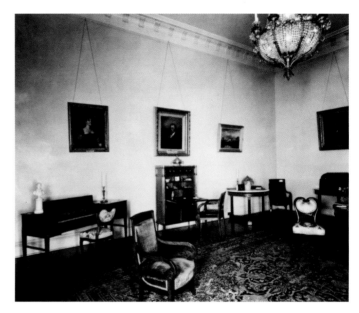

**MONROE ROOM,** *1932*

**DROP-LEAF TABLE** *(above), walnut, c. 1933, made by the Val-Kill Furniture Shop, Hyde Park, New York. U.S. Government purchase, 1933*

**WEST SITTING HALL** *(opposite), c. 1933–45*

TO BOLSTER EMPLOYMENT near her New York home, Eleanor Roosevelt founded the Val-Kill Furniture Shop on the family's Hudson River estate in 1927. Inspired by the opening of the American Wing of the Metropolitan Museum of Art in 1924, the goal was to "copy early American furniture, doing it as nearly as possible in the same ways as the early Americans did it."[28] Shortly after she became first lady in 1933, the White House bought eleven pieces of Val-Kill furniture, including a "butterfly" drop-leaf table like the one with leaves raised as seen in a photograph of the West Sitting Hall adjoining Mrs. Roosevelt's bedroom and sitting room. In 1934, one writer reported that "another really personal touch" given to the White House by the Roosevelts was the "abundance" of this Val-Kill furniture "confined to no particular period, but the so-called Dutch Colonial is thought to predominate."[29] The Val-Kill shop was a precursor to such New Deal agencies as the Works Progress Administration created by President Franklin D. Roosevelt to provide assistance during the Great Depression of the 1930s.

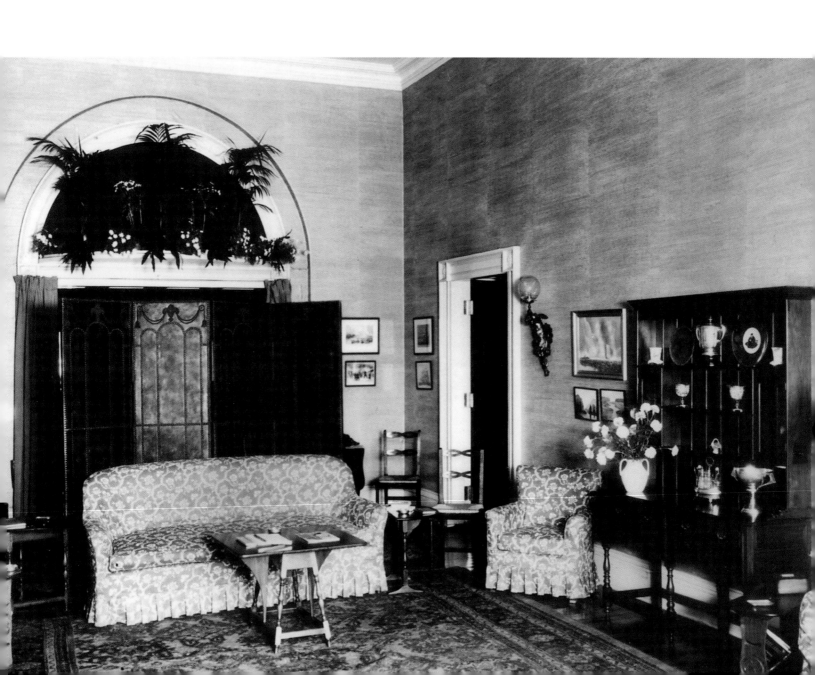

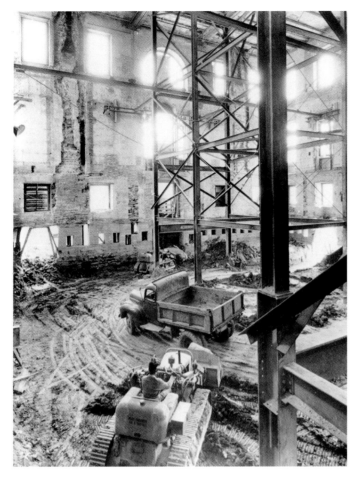

**WHITE HOUSE INTERIOR UNDER CONSTRUCTION DURING THE TRUMAN RENOVATION** *(above), 1949, photograph by Abbie Rowe, National Park Service*

**MANTEL** *(opposite), painted pine, c. 1902, made by Norcross Bros., Worcester, Massachusetts, in place in a Second Floor bedroom. U.S. Government purchase, 1902*

IN 1948, PRESIDENT HARRY S. TRUMAN discovered that the interior of the White House was close to collapse after 150 years of heavy use. The need for quick structural improvements prompted Congress to authorize the "Truman renovation" of 1949–52 by the Army Corps of Engineers. The solution was the removal of most of the interior of the building to excavate basements and erect a steel frame around which to rebuild and modernize. Photographs were taken of the interiors—many of them with 1902 ceilings or wall coverings over prior elements dating back as far as 1817—as they were disassembled for possible reuse or simply destroyed. Many of the mantels were donated to museums and historical organizations, while some impressive 1902 architectural elements were given away. More modest fragments of the building—a brick, a nail, a piece of wood—were made available to the public as souvenirs for the cost of shipping and handling. This mantel, sent to Blair House, the President's Guest House, was transferred back to the White House.

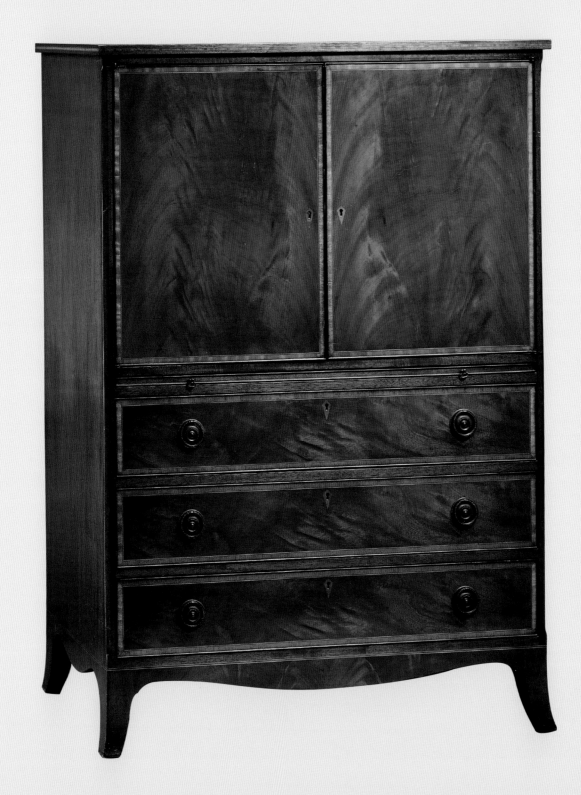

As a part of the Truman renovation, the refurbishing of the rebuilt interiors of the White House was overseen by the design department of the New York department store B. Altman & Company. A large quantity of furniture, mostly reflecting antique styles, was acquired in 1951–52; much of it came from the "Beacon Hill Collection" of the Kaplan Furniture Company, a firm that specialized in reproducing or adapting fine antique furniture. Illustrated both open and closed in the Beacon Hill catalogs was a case piece described as "Sheraton High Chest, re-created from American design of the period 1790" and as "Chiffonier. . . . Ideal chest for the head of the house."[30] One of these chests was acquired for use in the White House bedroom of President Harry S. Truman.

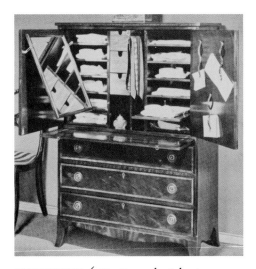

**CHIFFONIER** (*opposite, and catalog image, above*), *mahogany, c. 1951, made by Kaplan Furniture Company, Cambridge, Massachusetts. U.S. Government purchase, 1952*

**PRESIDENT HARRY S. TRUMAN'S WHITE HOUSE BEDROOM** (*above*), *1952, photograph by Abbie Rowe, National Park Service*

IN JANUARY 1958, the White House received a large collection of gilded silver—mostly eighteenth- and nineteenth-century pieces made in England and France—as a bequest of Mrs. Margaret Thompson Biddle. Heiress to a Montana mining fortune, Mrs. Biddle had been a famous hostess in Paris, entertaining such notables as General and Mrs. Dwight D. Eisenhower and the Duke and Duchess of Windsor. According to her daughter, she decided at a White House dinner to leave her collection, from her homes in New York and Europe, to the U.S. government for use in the White House. Much of the collection was exhibited on the Ground Floor in the newly created Vermeil Room, named for the French term for this gilded silver. A small selection of interesting or representative pieces remain on display there, while a variety of other pieces—candelabra, vases, dishes—have been used to ornament some of the public and private rooms. Two pairs of tureens in the collection were made in 1778–79 to designs by the English architect Robert Adam for the Duke of Northumberland, whose son James Smithson left a bequest to create the Smithsonian Institution.

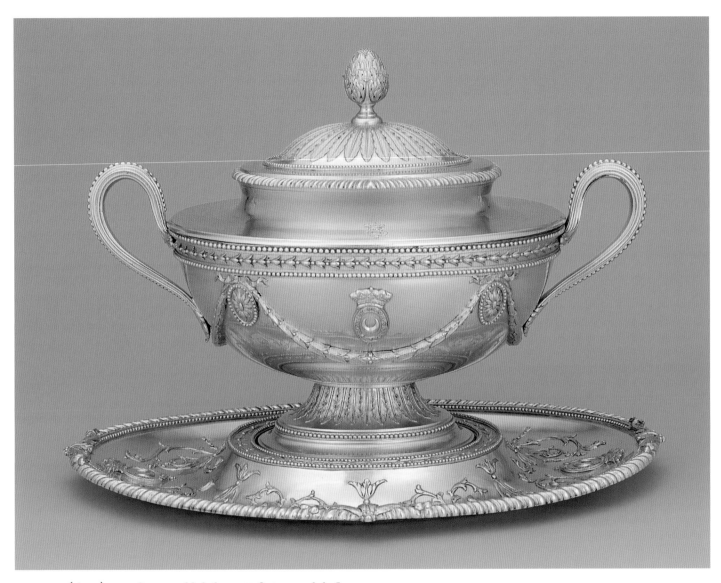

**TUREEN** *(above), one of a pair, gilded silver, 1778–79, made by James Young, London. Bequest of Margaret Thompson Biddle, 1957*

**VERMEIL ROOM** *(opposite), 1960*

SEVERAL OF THE FIRST OBJECTS ACQUIRED for the White House collection under First Lady Jacqueline Kennedy were placed in the Green Room, for which Grace Coolidge had tried to collect period furniture in the late 1920s. Furniture in the Federal style, made in the first two decades after the ratification of the Constitution of the United States, 1789–1810, was especially popular with one of Mrs. Kennedy's advisers, the noted collector and scholar Henry Francis du Pont, whose support for her White House project attracted the attention of other important collectors and philanthropists. In 1961, donated funds were used to purchase for the Green Room a graceful Federal sofa made in Portsmouth, New Hampshire, c. 1800, once owned by the senator and statesman Daniel Webster, and a Baltimore demilune card table skillfully inlaid with thistles, seashells, and bellflowers.

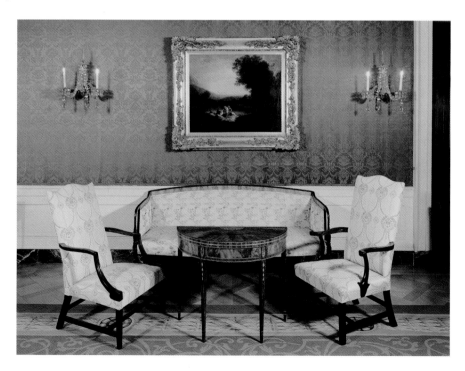

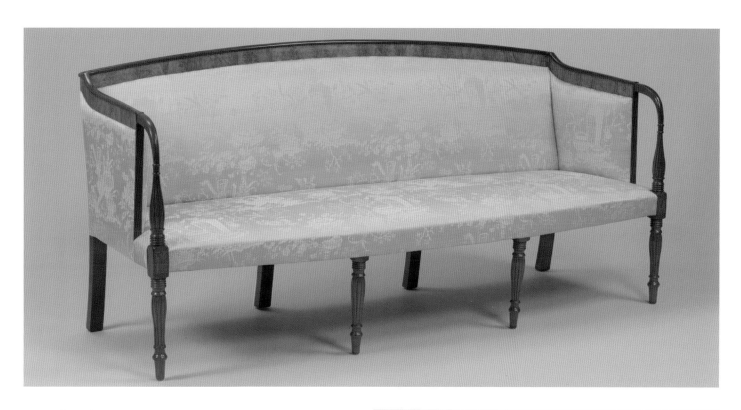

**SOFA** *(above), mahogany and satinwood, c. 1800, Portsmouth, New Hampshire. Gift of Mrs. Albert Lasker, 1961*

**GREEN ROOM** *(opposite), 1962*

**CARD TABLE** *(right), mahogany, c. 1800, Baltimore. Gift of Mrs. Fred T. Couper*

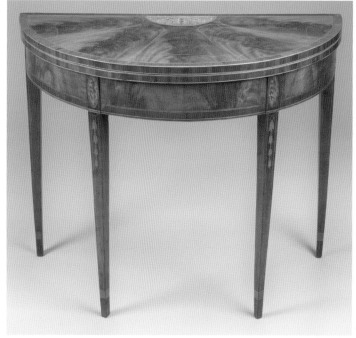

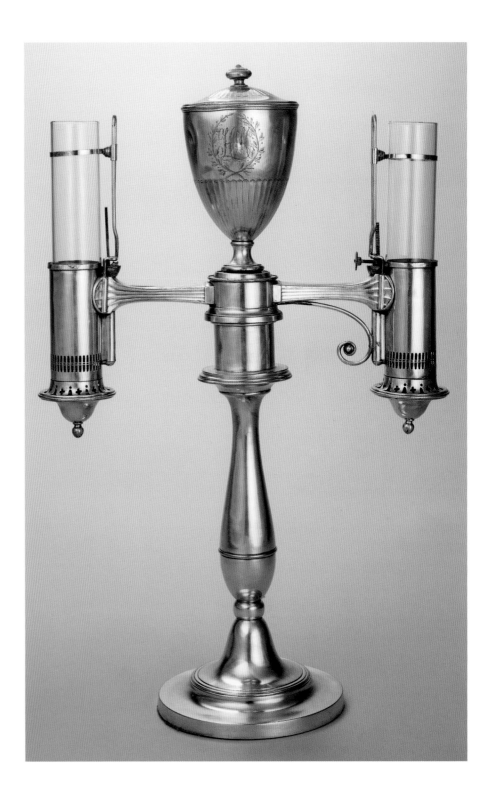

EARLY IN FIRST LADY JACQUELINE KENNEDY'S celebrated program to fill the White House with furnishings contemporaneous with the early decades of White House history, the American Institute of Interior Designers offered to fund improvements to the Library. Its donations included a pair of English silverplate Argand lamps believed to have been presented by the Marquis de Lafayette, during his first return visit to the United States in 1784, to his friend and comrade in arms, Major General Henry Knox, commander of artillery in the American Revolution. The more clean and efficient oil burner in this style of lamp was named for its Swiss inventor, Aimé Argand, who went into business with Matthew Boulton, the foremost English manufacturer of silverplate and brass, to produce lamps in many forms. Called the "Louis" model after Argand's 1785 gift of such lamps to King Louis XVI of France, this model was also owned by George Washington.

**ARGAND LAMP,** *Sheffield silverplate, 1784,*
*made by Matthew Boulton, Soho, England.*
*Gift of the American Institute of Interior Designers, 1962*

A MARVELOUS "LIGHTHOUSE CLOCK" made by Simon Willard, one of a famous family of Massachusetts clocksmiths, was also purchased for the White House Library as part of the room's 1961–62 refurbishment. In 1822, Willard advertised that "the President of the United States [James Monroe] has granted him a PATENT RIGHT for his newly invented ALARUM TIMEPIECE."[31] The advertisement was illustrated with an engraving of a clock, much like this alarm-fitted timepiece, designed to resemble the famous Eddystone Lighthouse off Plymouth, England. This clock, however, is unusual for the sulphide medallion portrait of the Marquis de Lafayette, who, at the invitation of President James Monroe and the Congress, made a year-long "Triumphal Tour" throughout the United States in 1824–25. He was received by his friend Monroe at the White House on several occasions in the fall and winter and stayed at the White House with President John Quincy Adams in the summer of 1825. During his visit, the park north of the White House was named Lafayette Square. Shortly after his return to Paris, Lafayette sent Monroe a small bronze bust of himself, the original of which is believed to be the source for the commemorative portrait on this clock.

**SHELF CLOCK,** *mahogany, c. 1825,*
*made by Simon Willard & Son, Roxbury, Massachusetts.*
*Gift of Mr. and Mrs. A. H. Meyer, 1961*

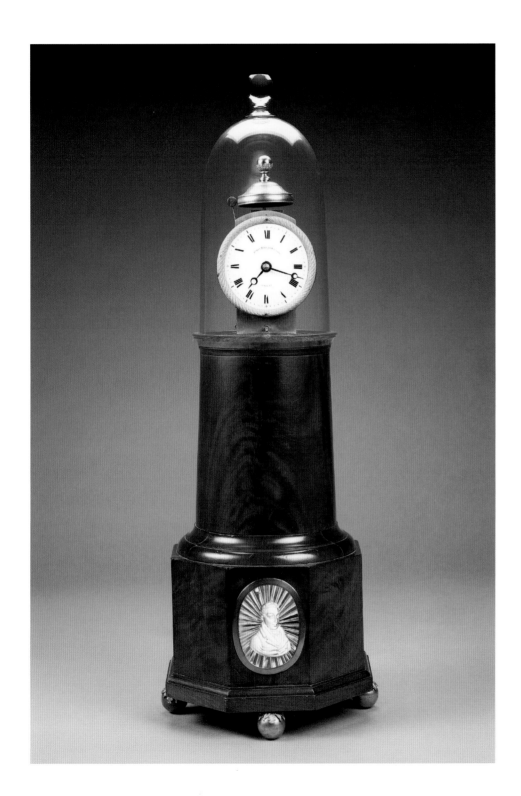

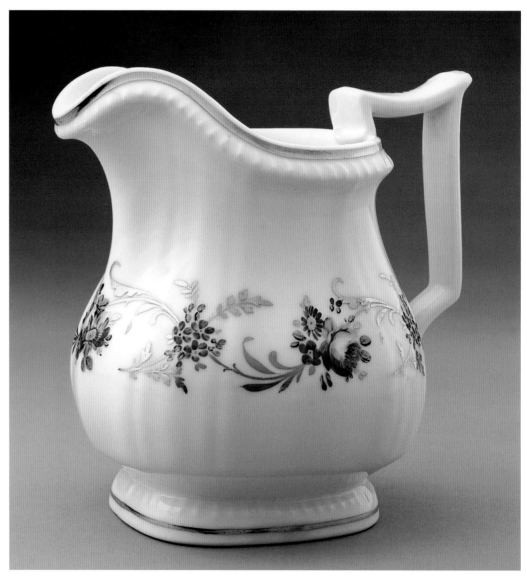

**PITCHER,** *porcelain, 1828, made by Tucker & Hulme, Philadelphia.*
*Gift of Mr. and Mrs. Raymond G. Grover, 1962*

IN AN ATTEMPT TO MANUFACTURE American porcelain that could successfully compete with imports from Europe and the Far East, William Ellis Tucker opened a relatively short-lived Philadelphia factory in 1826. Trying to cope with financial burdens, he took in a series of partners, including John Hulme for a few short months in 1828. After receiving a gift of porcelain from Tucker in 1830, President Andrew Jackson wrote: "I was not apprised before of the perfection to which your skill and perseverance has brought this branch of American manufacture. It seems to be not inferior to the finest specimens of French porcelain."[32] Although Jackson would order a service of Tucker china for his home in Tennessee, Tucker's firm failed in 1838. The White House would not buy a service of American-made china until 1918, when the Woodrow Wilson state service was made by Lenox in Trenton, New Jersey. This marked Tucker & Hulme pitcher was donated to the White House to represent that early attempt at American porcelain manufacture.

First Lady Pat Nixon initiated a second major phase of collecting for the White House in the early 1970s, including the acquisition of a large collection of New England Federal furniture by the talented father-son cabinetmakers, John and Thomas Seymour of Boston. A tall case clock initialed by John Seymour was placed in the Oval Office, where it remains today, while Seymour case furniture and tables were placed in the Queens' Bedroom on the Second Floor. In 1974, this handsome desk with bookcase was purchased as an addition to the White House collection of Seymour furniture. The importance of the collection inspired the scholar Robert Mussey, with a grant from the White House Historical Association, to begin at the White House as he compiled his study of the product of the Seymour shop.[33]

**DESK AND BOOKCASE**, *mahogany, c. 1798–1808, made by Thomas Seymour (1771–1848), probably with John Seymour (c. 1738–1818), Boston. Gift of an anonymous donor and the White House Historical Association, 1974*

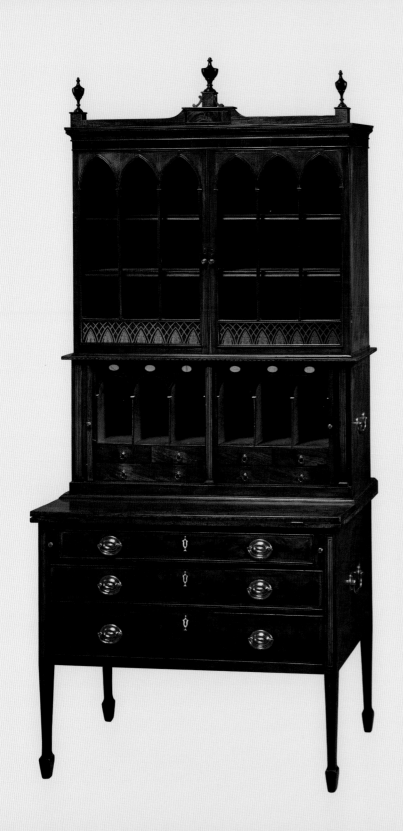

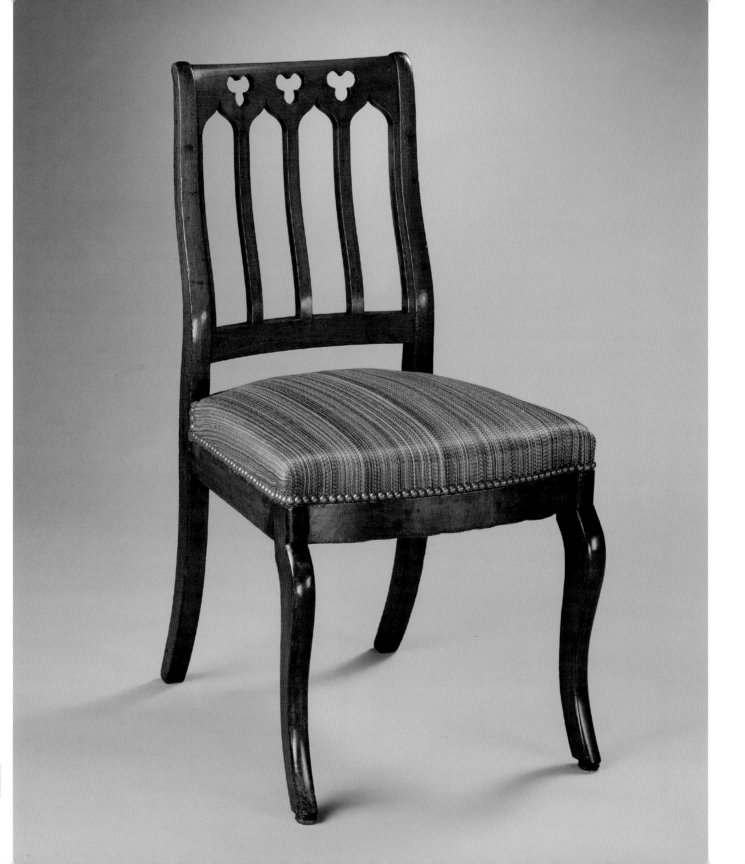

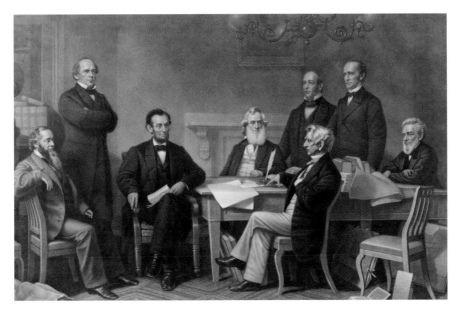

**THE FIRST READING OF THE EMANCIPATION PROCLAMATION BEFORE THE CABINET** *(above), engraving by Alexander H. Ritchie (1822–1895), after Francis B. Carpenter (1830–1900), 1866*

**SIDE CHAIR** *(opposite), black walnut, c. 1846, made by J. & J. W. Meeks, New York. U.S. Government purchase, 1846*

THE EARLIEST PRESIDENTIAL OFFICES were located on the State Floor, but for much of the nineteenth century the offices were upstairs in the residence, sharing the Second Floor with the first family's private quarters. During the Civil War, President Abraham Lincoln's office also served as his Cabinet Room, where he would meet with the leaders of the executive departments. In 1864 the artist Francis B. Carpenter spent six months in the White House to accurately re-create on canvas one momentous cabinet meeting in 1862, when Lincoln first read his proposed Emancipation Proclamation freeing African Americans held in slavery in the southern states in rebellion against the federal government. Around the plain table the cabinet sat in walnut side chairs purchased by President James K. Polk in 1846 from New York furniture makers, J. & J. W. Meeks, a leader in the national marketing of fine furniture. Called "Gothic" for the crest rail piercings, these chairs were not a special commission, but they show clearly in the Carpenter painting and the engraving made from it. In 1945, to honor Lincoln's leadership, President Harry S. Truman directed that Lincoln era furnishings, including four surviving Meeks chairs, be assembled in the room that had been Lincoln's office, now the Lincoln Bedroom.

PRESIDENTS FOLLOWING ABRAHAM LINCOLN have had an office and a separate Cabinet Room. In 1869, President Ulysses S. Grant commissioned Pottier & Stymus Manufacturing Company, a New York maker of furniture for the luxury trade in America, to redecorate his Cabinet Room. An elaborate conference table, now used as a desk in the president's private office on the Second Floor, was accompanied by a large sofa ornamented with the shield from the Great Seal of the United States. At the same time, the Cabinet Room mantel was outfitted with an imposing French clock with a marble and malachite case that also contains a barometer, thermometer, and perpetual calendar.

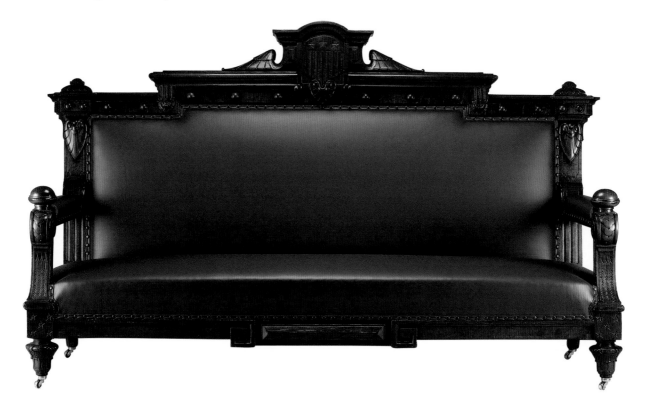

**MANTEL CLOCK** (*right*), *marble, c. 1869, France.*
*U.S. Government purchase, 1869*

**CABINET ROOM** (*below*), *c. 1889*

**SOFA** (*opposite*), *black walnut, 1869, made by Pottier & Stymus*
*Manufacturing Company, New York. U.S. Government purchase, 1869*

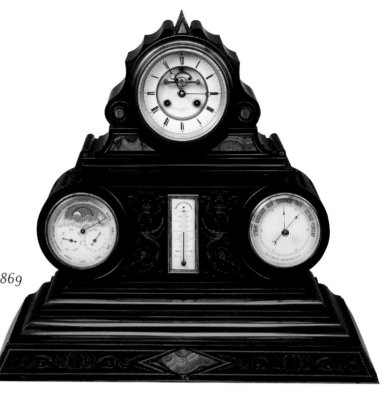

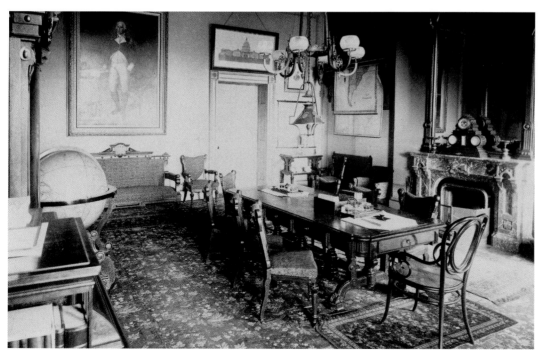

TO PROVIDE THE FIRST FAMILY WITH GREATER SPACE and privacy, President Theodore Roosevelt had his office suite moved in 1902 from the residence to a new "Executive Office Building," today known as the West Wing. Although oval rooms are a well-known feature of the White House, the famous Oval Office was not created until a 1909 expansion of Roosevelt's wing. Badly damaged by a Christmas Eve fire in 1929, the Oval Office was refurnished in 1930, including some fire-surviving West Wing armchairs made in the English Regency style popular in America in the early nineteenth century. These chairs, still in use today in the Oval Office, were provided by A. H. Davenport & Company, which made furniture for many of the projects directed by McKim, Mead & White, architects of the West Wing and the Theodore Roosevelt renovation of the White House in 1902.

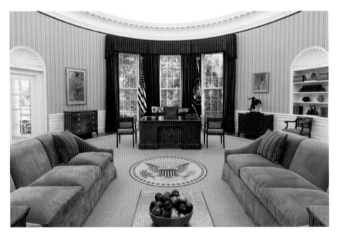

**THE PRESIDENT'S OVAL OFFICE** (*above*), 2010

**ARMCHAIR** (*opposite*), *mahogany, 1902, made by A. H. Davenport & Company, Boston. U.S. Government purchase, 1902*

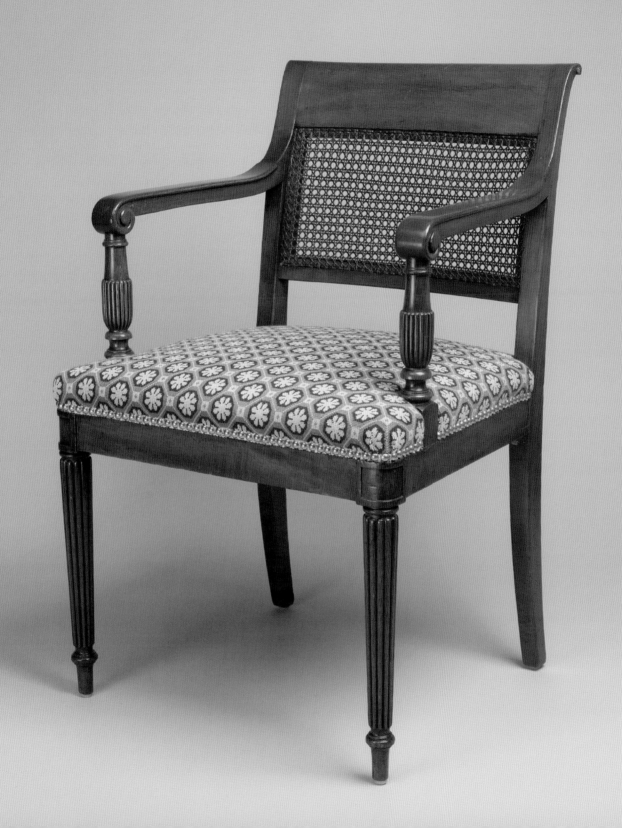

# ENDNOTES

1.  George Washington to James Madison, March 30, 1789, *The Writings of George Washington,* ed. John C. Fitzpatrick (Washington, D.C.: Government Printing Office, 1931–44), 30:255.

2.  John Adams to Abigail Adams, November 2, 1800, Adams Papers, Massachusetts Historical Society, Boston.

3.  Samuel F. B. Morse, letter of December 19, 1819, in *Samuel F. B. Morse: His Letters and Journals,* ed. Edward Lind Morse (New York: Kennedy Galleries, 1973), 1:227.

4.  *Speech of Mr. [Charles] Ogle, of Pennsylvania, on the Regal Splendor of the President's Palace: Delivered in the House of Representatives, April 14, 1840* (Boston: Weeks, Jordan, and Company, 1840), 6.

5.  *Remarks of Mr. [Levi] Lincoln, of Massachusetts, in the U.S. House of Representatives, April 16, 1840, In reply to Mr. [Charles] Ogle . . .* (Boston, 1840), 3.

6.  "The Lincolns Redecorate the White House," *San Francisco Daily Alta California*, May 12, 1862.

7.  Charles Moore, "The Restoration of the White House," *Century Illustrated Monthly Magazine* 65 no. 6 (April 1903): 825.

8.  Theodore Roosevelt to Cass Gilbert, December 19, 1908, American Institute of Architects Library, Washington, D.C.

9.  Quoted in Perry Wolff, *A Tour of the White House with Mrs. John F. Kennedy* (Garden City, N.Y.: Doubleday, 1962), 231–32.

10. Quoted in "Mrs. Cleveland's Hopes," *New York Times*, March 4, 1889.

11. Quoted in William Seale, *The White House: The History of an American Idea,* 2nd ed. (Washington, D.C.: White House Historical Association, 2001), 15.

12. Dolley Madison to Mary Latrobe, December 3, 1814, in Allen C. Clark, *Life and Letters of Dolley Madison* (Washington, D.C.: W. F. Roberts, 1914), 166.

13. Major General Henry Lee, *George Washington! A Funeral Oration on His Death, December 26, 1799* (London: J. Bateson, 1800).

14. James Monroe, "Message from the President of the United States upon the Subject of the Furniture Necessary for the President's House," February 10, 1818, 15th Cong., 1st sess. (1818), 1.

15. Joseph Russell to James Monroe, September 15, 1817, House Report 79, 18th Cong., 2nd sess. (1825), 221, National Archives, House of Representatives, Washington, D.C.

16. Russell to Monroe, April 10, 1824, ibid., 262.

17. "Statement of William Lee, Esquire, Agent for Procuring Furniture for President's House . . . ," March 9, 1818, House of Representatives Document, 15th Cong., lst sess. (1818), 5.

18. Thomas Hill Hubbard to Phebe Hubbard, February 21, 1818, copy in Office of the Curator, The White House, Washington, D.C.

19. Quoted in Esther Singleton, *The Story of the White House* (New York: McClure, 1907), 208.

20. Authors' correspondence with Ian Simmonds, 2009.

21. Montgomery Schuyler, "The New White House," *Architectural Record*, April 1903, 385.

22. Theodore Roosevelt to Kermit Roosevelt, November 1, 1905, and June 21, 1904, in *Theodore Roosevelt's Letters to His Children,* ed. Joseph Bucklin Bishop (New York: Charles Scribner's Sons, 1919), 143, 104.

23. National Archives, Miscellaneous Treasury Accounts 202494, voucher 36, December 23, 1875.

24. "Inventory of furniture &c in the President's House," February 28, 1867, National Archives, Records of the Commissioners of Public Buildings and Grounds, microcopy 371, roll 27, vol. 39, no. 3813.

25. Waldon Fawcett, "Rare Bric-a-Brac at the White House," *Ledger Monthly,* March 1902.

26. Count Ladislas Hoyoz, Austrian Minister to the United States, to Secretary of State Hamilton Fish, February 1, 1877, National Archives, Record Group 59, General Records Department of State, Notes, Austria, vol. 7, January 1, 1875–May 31, 1880.

27. Quoted in "First Lady Makes a Coverlet," *Washington Evening Star,* February 12, 1928, 33.

28. Nancy Cook, in conversation with Eleanor Roosevelt as recollected by Marion Dickerman, June 1925, in Kenneth F. Davis, *Invincible Summer: An Intimate Portrait of the Roosevelts* (New York: Atheneum, 1974), 45.

29. John Russell Young, "Changing a Mansion into a Home," *Washington Sunday Star*, March 4, 1934.

30. Kaplan Furniture Company, *The Beacon Hill Collection* (Boston, c. 1950–56), 159; Kaplan Furniture Company, *Selections from the Beacon Hill Collection* (Boston, c. 1950), 17.

31. Quoted in Brooks Palmer, *A Treasury of American Clocks* (New York: MacMillan, 1967), 54.

32. Andrew Jackson to William Ellis Tucker, April 3, 1830, quoted in Alice Cooney Frelinghuysen, "Tucker Porcelain, Philadelphia, 1826–1838," *Antiques,* April 1989, 927.

33. Robert D. Mussey, *The Furniture Masterworks of John and Thomas Seymour* (Salem, Mass.: Peabody Essex Museum, 2003).

## CREDITS

For fifty years, members of the White House curatorial staff have contributed to the store of knowledge about the White House and its collection, which resides in the files of the Office of the Curator. In 2000, the White House curator Betty Monkman produced *The White House: Its Historic Furnishings and First Families,* the seminal study of the decorative arts of the White House. Published by the White House Historical Association in honor of the two-hundredth anniversary of the first occupance of the White House, it is a rich source of information with photographs by Bruce White, many of which have been used in this catalog.

All artwork and objects are in the White House collection.

All images are copyrighted by the White House Historical Association (WHHA) unless listed below.

page 28, Engraving from Benson J. Lossing, *Pictorial History of the Civil War in the United States of America* (Philadelphia: George W. Childs, 1866), 1:435.

page 33: State Dining Room. Engraving from *Frank Leslie's Illustrated Newspaper*, April 1, 1871.